BANDSTANDS
OF BRITAIN

PAUL RABBITTS

The
History
Press

This book is dedicated to my delightful daughter,
Ellie Rabbitts.

Cover photograph by Daniel Fildes. (Courtesy of Dudley MBC)

Opposite: St Anne's on Sea.

First published 2014

The History Press
The Mill, Brimscombe Port
Stroud, Gloucestershire, GL5 2QG
www.thehistorypress.co.uk

British Library Cataloguing in Publication Data.
A catalogue record for this book is available from the
British Library.

ISBN 978 0 7509 5606 2

Typesetting and origination by The History Press
Printed in India

FOREWORD

In 1997 I was despatched to survey and assess an iron bandstand in Stair Park, Stranraer, which was to be refurbished by my firm, Heritage Engineering. After twenty years of examining these structures, this has proven to be the most dilapidated I have seen. What was delightful, however, was that it had not been altered or badly 'restored' and, whilst literally on its last legs, its simplicity and economy of design stood out. The exposed location meant there was little paint left on the surface and the fine quality of the grey iron castings shone through.

I had become increasingly interested in architectural cast ironwork since the early 1990s and had started to research the firms whose names were to be found beneath the layers of paint. Many of these were Scottish (but not always!) and I began to understand the pre-fabrication systems, pattern numbers and registered designs used by these wonderful firms. The Stair Park example, I learned, was a model 279 by the Saracen Foundry of Walter MacFarlane and Co. It was made in two sizes and is by far the most prolifically manufactured bandstand in the world,

with examples to be found from Australia to South America. For me it was the start of a fascination with these remarkable iron structures.

This was no small industry. Across the central belt of Scotland, tens of thousands were employed in the design and manufacture of architectural cast ironwork, yet until comparatively recently the scale and importance of these firms was not well understood. The Scots brought the highly skilled men of Coalbrookdale to Falkirk with the founding of Carron Ironworks in 1759 and learned their techniques. Carron was the mother ship from which dozens of other firms developed, spreading to the west along the Forth and Clyde Canal to Glasgow, which was to become the engineering heart of the empire. Using black-band ironstone, high in graphite and phosphorus and ideal for ornamental light castings, these firms initially supplied the demand for rainwater goods and sanitary castings as improvements were made to domestic sanitation. The explosion in decoration happened as the unit cost of cast-iron production made it affordable (as opposed to hand-forged work), the Great Exhibition happened and the firms switched on to the opportunities of elaborate decorative catalogues showing their wares in this new 'wonder material'.

Whilst the primary producers were Scots, English firms like Hill and Smith also made ornamental ironwork and fine bandstands in particular. Whilst the temperance movement and the diamond jubilee of Queen Victoria prompted a profusion

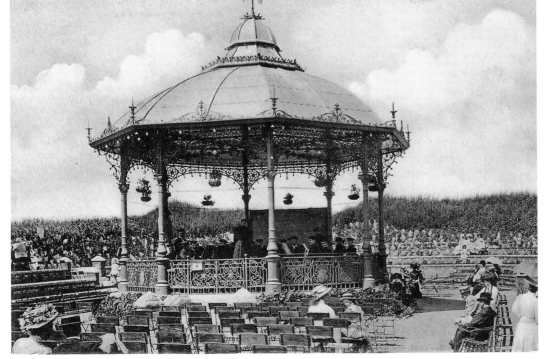

of commemorative iron fountains across the country, the bandstand was a larger undertaking, a centrepiece of an urban park funded by a local council or local benefactor. Stock designs allowed for personalised touches such as civic coats of arms or minor details changed – the bandstand was a piece of pre-fabricated civic ornamentation using sound engineering principles.

The evolution of the design tracks the maturation of the industry. Double columns gave way to single columns (easier to see the band and, more importantly, less expensive), roof structures became lighter using standard bosses, hubs to hold ceiling joists and baluster panels were finished by custom handrails neatly slotting into pre-cast column lugs, and drip frets concealed unfinished facings. It became a competition in ornamentation, and whilst the Saracen Foundry came out on top as ever, the Lion Foundry and the Sun Foundry of George Smith & Co. produced fabulous examples. Saracen produced over 100 examples of around 250 made in Scotland, even developing an export catalogue for the South American market. In terms of productivity, Lion came second (former employees of Saracen), followed by McDowall Steven & Co., James Allan's Elmbank Foundry and then George Smith & Co.

Post-Edwardian era, the rate of loss of these structures was staggering, however. It is largely thanks to the Heritage Lottery Fund and other heritage bodies that so many have been restored and in some instances remade to original designs. This has an aesthetic and social benefit of course, but it also helps to perpetuate the traditional skills and materials involved – many of which are on the verge of extinction. The establishment of the Scottish Ironwork Foundation in 2002 was a conscious effort to record architectural ironwork made or found in Scotland and to raise the profile of this important industry. Through our efforts and the advance of the internet, we have made many friends across the world who share our passion. Closer to home, Paul Rabbitts became an enthusiastic devotee of these unusual structures and turned to us for help in identification. We were pleased to help, and this book is an important milestone in increasing awareness of not only these important structures, but in telling the tremendous stories behind them.

The continued survival of these structures depends on a great many things but most important perhaps is that local people value them and understand their significance. I hope this book inspires others to study these structures and people like Paul continue to advocate their care.

Dr David S. Mitchell MSc IHBC
ProfMICME FSA Scot, 2014
Director of Conservation, Historic Scotland
Trustee, The Scottish Ironwork Foundation

ACKNOWLEDGEMENTS

Bandstands have been a passion of mine for many years. My first book in 2011 was simply called *Bandstands* and partly satisfied my obsession but, like many other fellow obsessives, it never stops there. Friends, family and colleagues have often asked me why and I am hoping this book answers that question; it is a celebration of Britain's bandstands, from Nairn in the north of Scotland to verdant Ventnor Park on the Isle of Wight. It celebrates the design of these wonderful icons of our parks and public places and tells the many stories associated with them.

Firstly, the Heritage Lottery Fund should be applauded for the £650 million they have invested in our historic parks, restoring over 120 bandstands and ensuring the long-term sustainability of many of our historic bandstands. My thanks and appreciation is also given to the following: Dominic and Damian Liptrot from Lost Art for so many fantastic restorations over the last ten years; Jim Mitchell and David Mitchell from the Scottish Ironwork Foundation for keeping the legacy of Walter MacFarlane alive; Maurice Bradbury for his incredible knowledge of bandstands and sharing it with me; Friends groups and people like Yvonne Richardson from the Friends of North Lodge Park in Darlington for putting the pressure on and realising the value of our legacy of local bandstands and keeping them alive; Superact for the magnificent Bandstand Marathon, now Our Big Gig; David Lambert and Stewart Harding for simply appreciating them; Sarah Priestley and Mary Forsyth at Watford Museum; and Declan Flynn from The History Press for encouraging me to develop this as a book.

I would also like to acknowledge the following for images and information used in this book: Page 7 David Coke; Page 11 Richard Gerring; Page 21 Jim Richmond; Page 30 Dorman Museum, Middlesbrough Council; Pages 40–42 and 44–45 Library and Information Services, Leeds City Council, www.leodis.net; Cover and Page 57 Daniel Fildes, Dudley MBC; Page 57 Tameside MBC; Page 60 Friends of the Pump Room Gardens; Page 61 www.davidchantreyphotography.com; Page 66 Watford Museum; Page 66 English Heritage; Page 70–71 Andra Nelki; Page 72 Anika Mottershaw; Page 73 Nick Sarebi; Page 75–76 David Bebbington; Page 77 Friends of Beckenham Rec; Page 84 Bandstand Marathon 2012; Page 93 David Lambert. All other images are from my own collection.

My final thanks must go to my family, who finally appreciate the nuances of a Walter MacFarlane bandstand.

INTRODUCTION

Bandstands have been a feature of the British way of life for well over a century but after the Second World War an increasing number fell into disuse or were neglected. Sadly a large number were demolished as public parks went into a spiral of decline in the 1980s and 1990s. Fortunately, in 1997 the Heritage Lottery Fund started pumping millions into the restoration of parks and this has seen the rediscovery of bandstands and an impetus to see them made anew, which has continued for the last fifteen years. Parks historian and former director of the Heritage Lottery Fund, Dr Stewart Harding has described them as 'wonderfully exotic structures that are at once very familiar and also alien in their strange designs – looking like UFOs, Moorish temples, rustic cottages or Chinese pavilions'.

But what of their origins? The first domed bandstand – then called a 'band house' – is believed to be one erected in the Royal Horticultural Society's gardens in South Kensington, which went up in 1861 on its slender cast-iron legs. Iron was the wonder of the day: it was strong and yet it could be cast into delicate decorations. The industrial iron age coincided with paternalist councils creating municipal parks for the industrial terrace-dwellers to relax in. The *Middlesbrough Advertiser* wrote in October 1859 on how these new industrial towns cried out for parkland:

No place is so badly provided for the recreative department as ours … Sickly looking youth and pallid manhood would receive a boon indeed by the establishment of some recreative institution or the enclosure of some ground where cramped limbs might be exercised, and the mind be dragged from the everlasting monotony around us. The lobes of the lungs are nowhere so severely tested as here and it is paramount opinion everywhere that we live in the smokiest, unhealthiest hole in the kingdom.

Each park needed a focal point. A bandstand, with its rich decoration and its oriental shape inspired by the expansion of the empire into India, provided that. But a bandstand wasn't just decorative – it provided music, too. It was our Victorian forefathers who thought that 'good music would free the mind of urban griminess and humanise the industrial landscape'. At the height of their popularity during the Victorian era, bandstands were incredibly popular and attracted crowds of up to 10,000. Midweek concerts at Myatt's Fields, Lambeth were always extremely popular, especially on a Thursday night, right up until the Second World War. *Daily Express* writer Jack Donaldson described such a scene in 1937:

I arrived on time but there was no room on the seats or the railings, so I leant against a tree and enjoyed the music. The children danced to it, played ball to it, sang to it and ignored it, The grown-ups, all listening, sat round on their wooden seats or leant against the green railings and were happy.

But the real origins of British bandstands go right back to the great pleasure gardens of the seventeenth and eighteenth centuries, before our Victorian forefathers. The most famous of these was Vauxhall Gardens, which were situated in London. It combined music, illuminated fountains, hot-air balloons, tightrope walkers and firework displays for the rich and fashionable people. They were like the nightclubs of their day and drew enormous crowds from all over the country to the music pavilions, which hosted promenade concerts where the audience could stroll about while listening to the music. It was from these musical events that the bandstand evolved.

They soon became so popular that nearly every public park and seaside resort had one by the end of the nineteenth century, each trying to outdo the other's colourful and ornate designs.

However, it was three Glaswegian companies who came to dominate ornamental bandstand production. The biggest was Walter MacFarlane & Co., which in 1875 employed 1,400 workmen and eighty clerks, and covered 8 acres at its immense Saracen Foundry in Possilpark. The others included the equally impressive George Smith's Sun Foundry, the McDowall Steven's Milton Ironworks and the nearby Lion Foundry based in Kirkintilloch.

But the interest in these concerts waned in the 1950s as other attractions (such as the cinema, radio and TV) became increasingly popular. As a result many fell into disrepair. There was a brief revival in the late '60s when groups like Pink Floyd and Fleetwood Mac played a series of free bandstand concerts at Parliament Hill in London, but most parks were by now struggling. In the years between 1979 and 2001, more than half of the bandstands in historic parks across the country were demolished, vandalised or fell into a chronic state of disuse. But, as described earlier, the revival is under way and continues. Bandstands are being restored and re-used up and down the country and are becoming the focal points of restored and vibrant parks, not

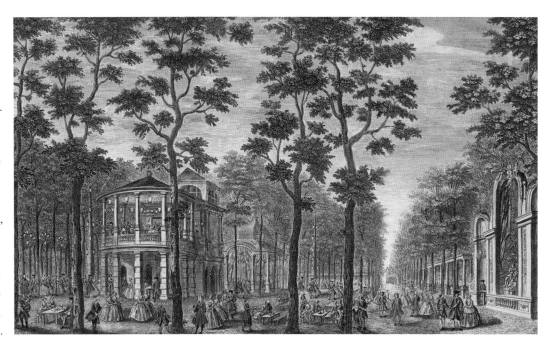

Vauxhall Gardens, from an engraving by J. Maurer of 1744 which shows the original orchestra stand.

just echoing to the sounds of brass, but often bouncing to rhythm and blues, rock, opera, street theatre and drama.

This book is a celebration of their designs and iconic status – as Stewart Harding described them, they are 'alien in their strange designs … yet exotic'.

The stories of many of Britain's bandstands are told here, from Aberdeen to the Isle of Wight, and the journey begins in the very birthplace of the ornate Victorian bandstand – Scotland, where bandstands were designed and fabricated and shipped across not just Britain, but worldwide.

SCOTLAND

A small number of Scottish foundries were the most prolific in making cast-iron products, and bandstands in particular. This was partly due to the discovery of black-band ironstone in 1802, followed by the invention of the hot blast process in 1828 by James Beaumont Neilson, which enabled vast reserves of iron ore to be processed cheaply and in a viable manner with pit coal. The abundant supply of coal and ore in Scotland, coupled with the suitability of the pig iron for ornamental ironwork, prompted the industry to develop in Scotland, in particular on the west coast.

Some of the finest bandstands were produced in Scotland and it is regrettable that so few remain here; despite the importance of the Glasgow foundries, none remain within the city's own parks. Yet of those that survive in Scotland, most have been restored to their former glory and are fine examples of the legacy of MacFarlane, Smith, and the others that were established during this most prolific of periods.

DUTHIE PARK, ABERDEEN

Duthie Park is one of the principal parks in Aberdeen and was gifted to the city by Lady Elizabeth Duthie of Ruthrieston in 1881. It was her desire to create a public park in the city to the memory of her uncle Walter and brother Alexander Duthie. This beautiful park was laid out and designed by the architect and surveyor Mr William R. McKelvie of Dundee, with the

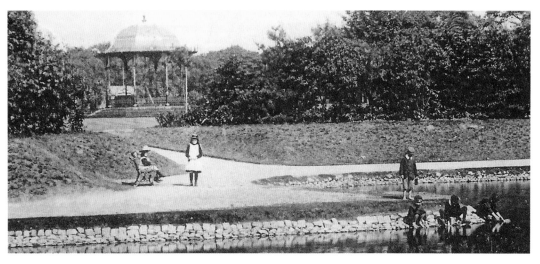

'first turf cut on 27 August 1881 by the Earl of Aberdeen, Lord Lieutenant of the County and Lady Duthie'. It was hoped that the queen would open the new park but she was recovering from an accident and so Princess Beatrice, who was in Aberdeen opening the Sick Children's Hospital bazaar at the music hall, officially opened Duthie Park on 27 September 1883. Erected in 1893, the park has a fine example of a restored McDowall, Steven & Co. bandstand, from the Milton Ironworks in Glasgow. An octagonal cast-iron bandstand on a granite plinth with five steps leading to the platform, it has barley twist cast-iron column supports stamped with the makers' name. Today, Duthie Park is still one of Aberdeen's most popular parks. Sadly, an equally impressive Sun Foundry bandstand, erected in the nearby Union Terrace Gardens in 1884, did not survive and was demolished in 1921.

Above: A rare view of the bandstand in Duthie Park, erected in 1893.
Right: The restored bandstand in Duthie Park.

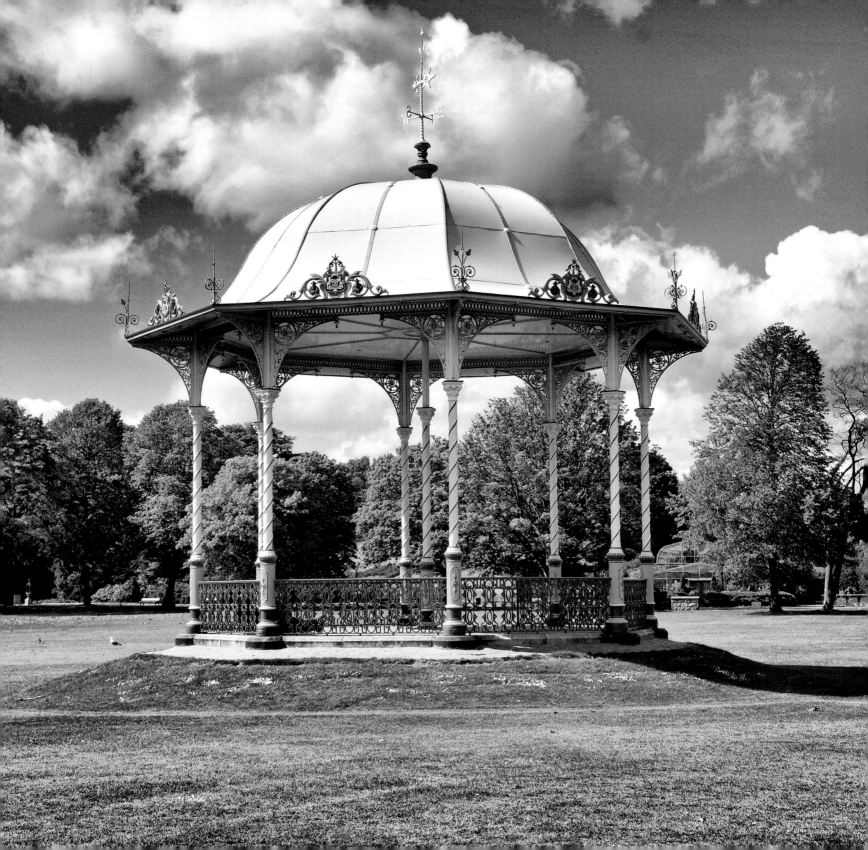

THE LINKS, NAIRN

Located on The Links in Nairn, this George Smith & Co. Sun Foundry bandstand was erected in 1884 and has a plaque attached stating:

Erected to the memory of John Wallace a native of Nairn who died at Ballark Australia 1882. A pioneer who became one of the most successful and respected pastoralists in the colony of Victoria. Ballan Shire Historical Society 1991.

This is easily the most northerly bandstand in the country and was beautifully restored in 2003 using the same colours as records indicated when it was originally constructed. This bandstand is used once again by the local community, for impressive local musical performances especially during the Nairn Jazz Festival each year as well as performances by the local military brass band each summer.

An early view of Nairn Links with the bandstand.

The restored dome and terminal.

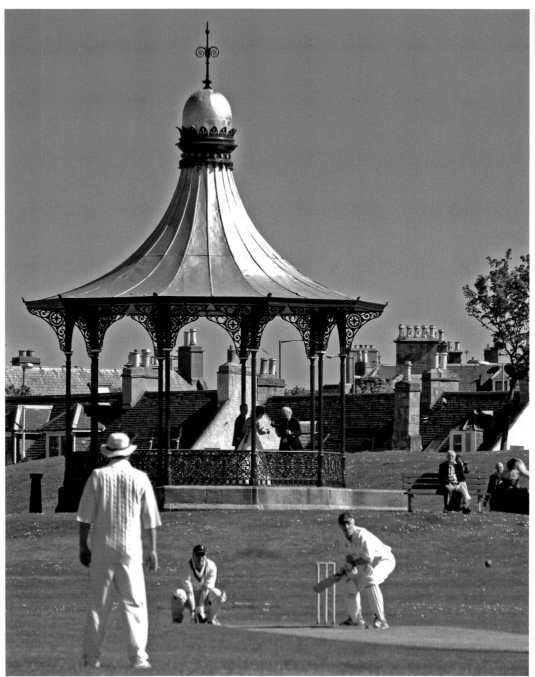

Nairn Links bandstand, central to the local community in so many ways!

At the turn of the twentieth century, one maker's name was dominant throughout the country: Walter MacFarlane & Co. of the Saracen Foundry, Glasgow. The MacFarlane Company was originally founded in 1850 and initially concentrated on the manufacture of sash weights for windows and sanitary and rainwater castings, particularly pipes and gutters, before moving into ornamental ironwork several years later. Wrought iron dominated their efforts in their early years before it switched to casting. They soon became world leaders as 'architectural, sanitary & general ironfounders', and the company ultimately made its name for the diversity, design and quality of its workmanship, marketing its products through extremely detailed and comprehensive catalogues. Two particular models from the catalogues were best-sellers and there are at least twenty known survivors of the No. 279 from the Manufacturer's Catalogue, including this excellent example at St Andrews in Fife installed in 1905. Other survivors include Horsham, Stockton-on-Tees, Darlington, Macclesfield, Ripon, Stoke-on-Trent, Lytham St Annes, Hathersage and Penzance.

At the turn of the century the Saracen Works' foundry covered 10 acres but increased in the

The detail in this MacFarlane No. 279 model has withstood the coastal elements of the North Sea on the green at St Andrews.

next few years to cover 24 acres. Bandstands were only part of its business and they ultimately merged into Allied Ironfounders which sadly went into liquidation in the 1980s. The mark of Walter MacFarlane has been made worldwide with bandstands from Australia, South Africa and Brazil.

A Walter MacFarlane No. 279 model bandstand in São João de Olinda, Brazil.

MAGDALEN GREEN, DUNDEE

In the City of Dundee is the beautiful and much-loved park, Magdalen Green. It is the oldest park in Dundee, and has been popular as an area for meetings, recreation, and social gatherings for many centuries.

Central to the Green, however, is a magnificent Walter MacFarlane Victorian bandstand that has since become the icon for the west end of Dundee. Opened in 1890, it is one of the oldest bandstands in

the country and was extensively restored in 1990 and further in 2009. Similar models exist in Exhibition Park, Newcastle upon Tyne, and a little further afield in Elder Park, Adelaide, Australia.

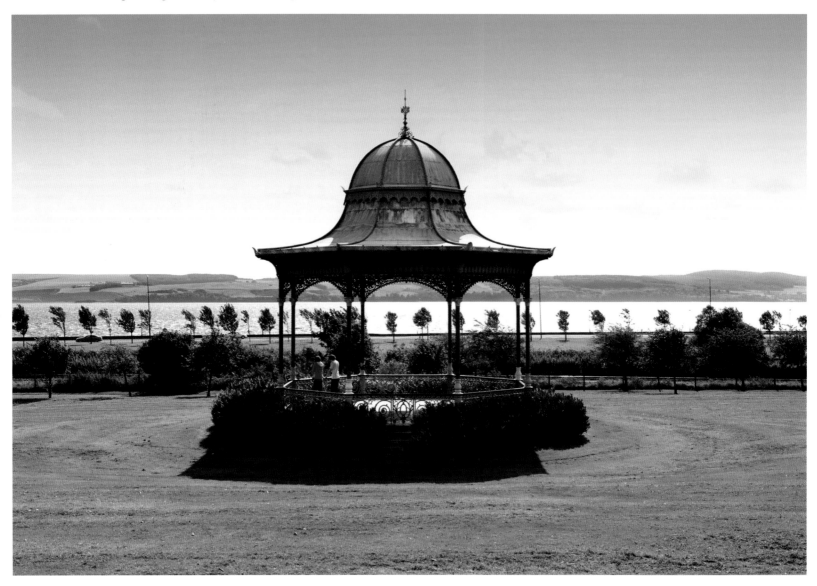

OVERTOUN PARK, RUTHERGLEN, LANARKSHIRE

One of MacFarlane's bandstands that survived is found just south of Glasgow in Overtoun Park, Rutherglen, installed in 1914. Overtoun Park was a gift to the town by the late Right Hon. Baron Overtoun (or John Campbell White to give him his ordinary name). White was also the owner of a large chemical works within the Burgh, and another gift he left the people of Rutherglen were hundreds of acres of contaminated land, much of which has had to be remediated at great expense. The bandstand was rescued and renovated for erection in the Glasgow Garden Festival in 1988 and was ultimately returned to its original home.

As mentioned previously, Glasgow had many cast-iron bandstands when the industry was firmly established in the city. These included the enormous Lion Foundry bandstand in Elder Park in Govan, installed in 1903 and possibly replacing an earlier one, which was present in 1891. Another cast-iron bandstand was present in Phoenix Park, Cowcaddens, installed as early as 1894, and an ornate structure in Springburn Park from the MacFarlane Foundry, this time installed at the bequest of James Reid in 1891. But two bandstands have dominated the Glasgow scene for nearly a century: the Kelvingrove Bandstand to the north of the Clyde and the Queen's Park Arena to the south of the Clyde.

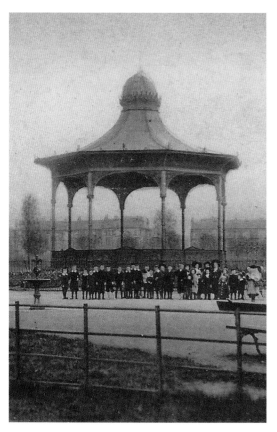

The giant Lion Foundry bandstand erected in Elder Park, Govan in 1903.

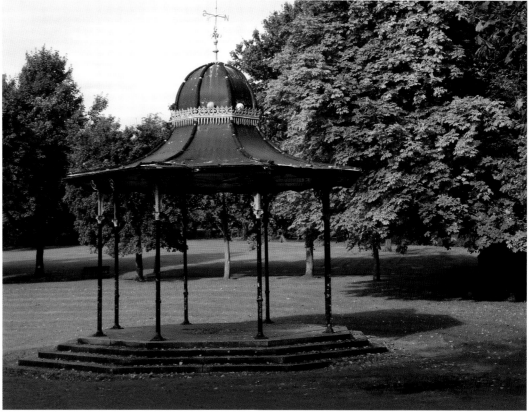

Overtoun Park bandstand, in poor condition, 100 years old and looking somewhat forlorn.

KELVINGROVE AND QUEEN'S PARK BANDSTAND, GLASGOW

The historic Kelvingrove bandstand dates from 1924–25 and was either designed by James Miller, or possibly designed by the in-house City Parks Department – it is not entirely clear, which is unusual for such an iconic and well-known bandstand. The bandstand is especially unusual for its impressive amphitheatre seating and certainly for its striking riverside location. The bandstand fell into disuse in recent years despite being incredibly popular for band concerts in the 1950s through to outdoor gigs in the 1990s, and became sadly extremely derelict. The Kelvingrove bandstand was eventually listed as Category B in 2000 as it was recognised as a rare example of its type and has since been the subject of an extremely ambitious community-led scheme to restore this vital facility as a venue for a large range of outdoor events and open-air performances. Works eventually began in August 2013 and were project managed by the Glasgow Building Preservation Trust who were hoping to give the historic bandstand a £2-million new lease of life for future generations.

Queen's Park Arena began life at the end of the nineteenth century with the original bandstand being a circular wrought and cast-iron construction by Walter MacFarlane's Saracen Foundry. Erected elsewhere within Queen's Park during the 1890s, by 1912 it had been relocated to the present location and was in use for a wide range of concerts, political rallies, public meetings, and many other events. By 1920 the bandstand was relocated to Duchess Park in nearby Motherwell and the Queen's Park site was left vacant for another ten years. Eventually a new bandstand was designed and built in 1930 – but this one was significantly different and was a rendered brick building with a south-facing stage

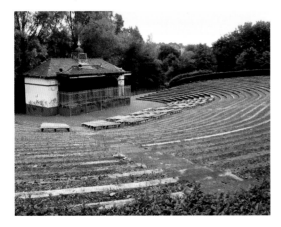

The derelict bandstand in Kelvingrove Park, host to many concerts over the years.

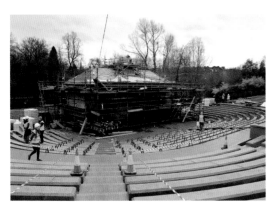

Restoration under way in 2013.

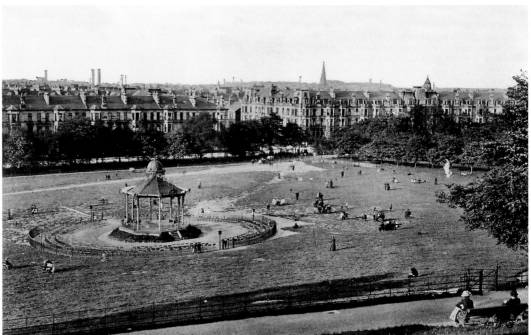

Queen's Park bandstand erected in the 1890s.

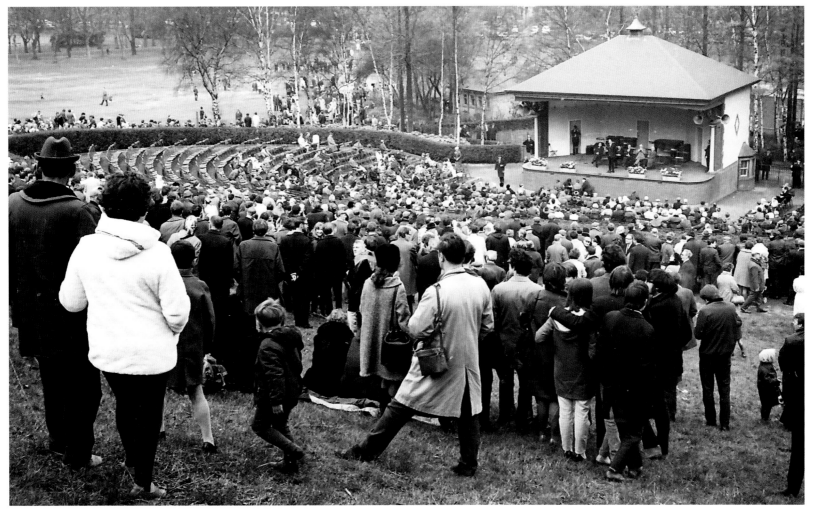

May Day Parade in the late 1960s at the Arena in Queen's Park.

rather than the more usual octagonal or circular structure found in many parks elsewhere. Carved into the natural amphitheatre were wide terraces to accommodate folding chairs, some of which still survive to this day. Sadly though, in 1996 the bandstand was destroyed by fire. It was not repaired or replaced and the terracing fell into complete dilapidation.

Many years passed but in 2009 a group of people from the local community councils which surrounded the park took it upon themselves to see whether local people and the community saw a need for its restoration and whether they would support it. Extensive community consultations were carried out between 2009 and 2011 along with preliminary surveys, initial design proposals and cost estimates

with over £180,000 raised to allow the first phase of restoration start. To take the project forward and to ensure the arena was sustainable, Queen's Park Arena Ltd was established. This was registered as a charity and company limited by guarantee. The first phases of ground consolidation and restoration of the site took place between 2011 and 2012 with many of the works continuing into 2013.

PUBLIC PARK, DUNFERMLINE

Along with Pittencrieff Park, the other large area of designed open space in Dunfermline is the Public Park on the east side of the town. Here, the most famous gardener and architect of his day, Sir Joseph Paxton, was consulted on the initial layout of the park in 1864–65, but the final plan was drawn up by his assistant, G.H. Stokes, after Paxton's death. The scheme was applied to the northern part of the land in 1866, with the southern area detached for formation of the railway. The design consisted of a serpentine network of paths through open parkland that maximised views out towards the Firth of Forth. The Donald Fountain is located at the park's highest point and is a wonderful example of a municipal drinking fountain built in pink granite. It was the gift of local Provost Donald in 1877.

However, the impressive bandstand is the work of Walter MacFarlane and Co. and was gifted by Mrs Louise Carnegie, the wife of philanthropist Andrew Carnegie, on her visit to Dunfermline in 1887. Born in Dunfermline, Andrew Carnegie emigrated to the United States with his parents in 1848 who were at the time very poor. His early career was as a telegrapher. However, by the 1860s he had investments in railroads, railroad sleeping cars, bridges and oil derricks. His wealth increased further as a bonds salesman where he raised money for American enterprise in Europe. He was responsible for building Pittsburgh's Carnegie Steel Company, which he eventually sold to J.P. Morgan in 1901 for $480 million (the equivalent of approximately $13.5 billion in 2013), and thus created the US Steel Corporation. Carnegie then devoted the remainder of his life to his greatest love – large-scale philanthropy, with considerable emphasis on world peace, local libraries, scientific research as well as education. It was his belief that the rich and wealthy had a moral obligation to donate their fortunes, and as a result he donated over $56 million himself to ensure that more than 2,500 public libraries could be built throughout the English-speaking world. He was a true philanthropist in every way.

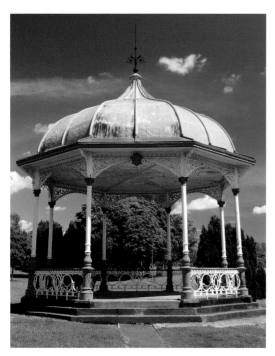 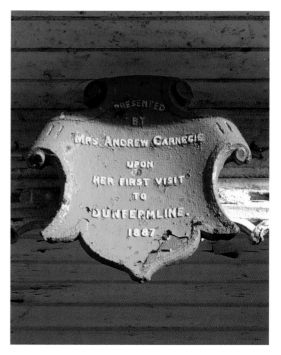

The impressive MacFarlane bandstand donated by Mrs Louise Carnegie in 1887 with fine details in the columns and a dedication plaque remaining in situ.

WHITEHILL PARK, HAMILTON

The decline of public parks in the 1970s and '80s was significant, with evidence collated in the '90s that features such as glass houses, paddling pools, fountains and bandstands were being lost at an alarming rate. One authority even went as far as stating that 'park buildings are a maintenance liability and can attract vandalism' and if not listed 'will be progressively eliminated'. Despite significant funding now being available for restoration, there are still buildings and features within parks at risk. This Walter MacFarlane No. 279 bandstand erected in Whitehill Park in Hamilton in 1912 was presented by John Menteath of Eddleston and remains in poor condition.

LEWISVALE PUBLIC PARK, MUSSELBURGH

Musselburgh Town Council erected an infectious diseases hospital on part of the site of the former estate of Eskgrove which had been purchased by them in 1910. The remainder became what is today known as Lewisvale Public Park, designed by Edinburgh city gardener, John McHattie. Douglas and Julius Brown gifted this Lion Foundry of Kirkintilloch bandstand to Musselburgh in memory of their father. He had served for many years as a bailie on Musselburgh Town Council. The bandstand cost around £200 in 1913 and was graciously accepted without objection by the council as 'the necessary equipage of a park', which they admitted at the time they would have had to provide themselves at a later date. It opened on 12 June 1914 and, addressing the gathering, Mrs Brown said 'she hoped the band programmes would always include popular Scottish music as well as classical pieces'. The bandstand was still echoing to the sound of bagpipes as recently as 2012 in celebration of the annual Bandstand Marathon.

GIRVAN

Bandstands on seafronts were becoming popular as resorts grew rapidly in the Victorian era, not only in such holiday destinations as Brighton, Clacton, Blackpool and Southend but also in Scotland such as Ayr, Musselburgh and here in nearby Girvan in South Ayrshire. Stair Park is Girvan's popular shorefront park and has ever been a favourite with local people and tourists, especially in its heyday. Remnants of the sand dunes from which it was formed can still be seen from its undulating form. The park today still offers a vast expanse of open space next to the shorefront and has done since it was gifted to the burgh in 1875 by the Countess of Stair.

The park still has one main focal point which is the war memorial, and which is an important memorial to those who died not just in the First World War, but also the Second World War. However, at the southern end of the park, next to the cemetery, are the semi-derelict remnants of a Victorian bandstand, an important structure as it is the last remaining bandstand of this era in South Ayrshire. There is a strong community desire to restore it but, sadly, little has happened, and this unusual bandstand remains neglected.

Stair Park bandstand, Girvan in its prime.

The rather sad and currently derelict J&A Law bandstand on the seafront in Girvan, South Ayrshire.

MACROSTY PARK, CRIEFF

MacRosty Park is Crieff's largest and most popular public park. The park was laid out and gifted to Crieff by James MacRosty in 1902 for 'the purpose of public enjoyment and recreation'. The bandstand was manufactured by James Allan Senior & Son at Elmbank Foundry in Glasgow in 1906, having been gifted by Alexander MacRosty, James MacRosty's brother. It is remarkably the only known Scottish example of this foundry, despite being relatively local. Other remaining Elmbank Foundry bandstands include the Leas at Folkestone, Swindon, Sherborne, Neath and South Shields. This unique bandstand with wonderful views to the Strathearn Hills quickly became a popular focus for concerts and entertainment and has to be one of the most stunning settings for such a simple but elegant bandstand.

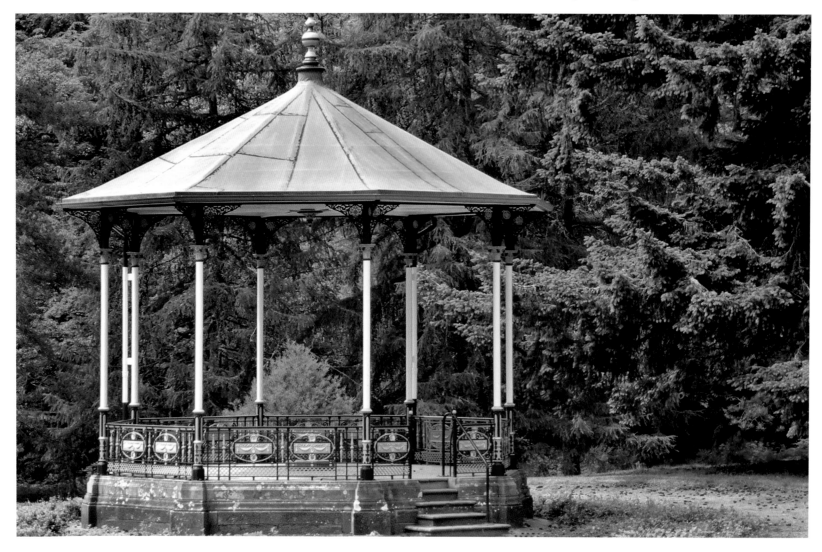

WEST PRINCES STREET GARDENS, EDINBURGH

Edinburgh is another city that has lost its original bandstands. Although surprisingly limited in numbers, excellent bandstands were found on the Meadows, a Lion Foundry bandstand erected in 1908 and demolished in 1953. Its twin was another Lion Foundry bandstand erected in Saughton Park, dismantled in the 1980s and still in storage with Edinburgh City Council who one day hope to re-erect it in the city. However, situated in West Princes Street Gardens, is one of the most well-known and loved bandstands in Scotland – the Ross Bandstand. It was originally built in 1877 and gifted to the city by William Henry Ross who was Chairman of the Distillers Company Ltd. The bandstand and adjacent terraced area were developed in 1935 and it has been the host to a wide number of rock, pop and brass bands, plays, orchestras and classical concerts over many years, including the annual international Edinburgh Festival. But before the Ross Bandstand, a cast-iron bandstand existed. It was erected in the late 1890s, was probably another MacFarlane structure and was almost certainly more elegant than the current incumbent.

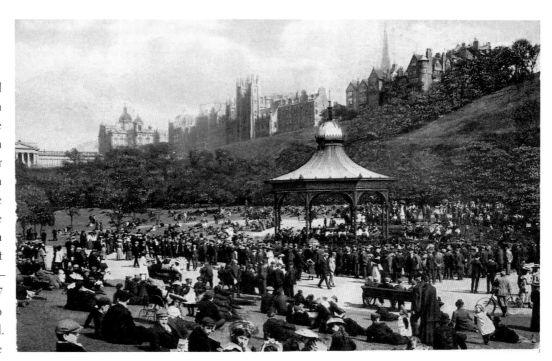

West Princes Street Gardens, Edinburgh.

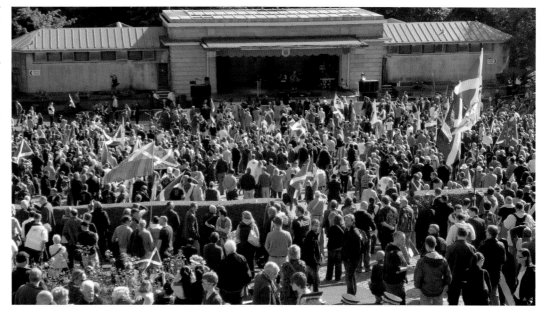

Independence for Scotland Rally at the Ross Bandstand, West Princes Street Gardens, Edinburgh.

ENGLAND AND WALES

LEAZES PARK AND EXHIBITION PARK, NEWCASTLE UPON TYNE

The oldest public park in Newcastle upon Tyne, Leazes Park is situated in the heart of the city. Opened in 1873, like many parks it had lost many of its original features including the bandstand, which was first shown on Reid's Plan of Newcastle and Gateshead from 1879.

On 12 March 1875, the council accepted a tender from George Smith & Co. Sun Foundry of Glasgow for an ornamental bandstand, costing £155 10s. The platform for the bandstand was commissioned by April, and constructed to a height of 3 feet and diameter of 30 feet. A year later it was suggested that canvas blinds be bought for the bandstand and there was a proposal to install glass shutters. A ten-sided polygon constructed from cast iron, this impressive and eloquent bandstand was built on a concrete plinth and painted with a finish that included the columns and guttering with pillars designed with a barley-sugar pattern. With cast-iron balustrading

and large spandrels, the original bandstand was very ornate and typical of a Sun Foundry bandstand. The extravagance even went as far as the design and construction of the roof, which was an ornate curved structure including a cupola, and would have had a cast-iron spider and tie rod at its core. Even the lightning conductor appears

to have been an ornamental design. Sadly it was ultimately dismantled and removed during the Second World War, presumably to aid the war effort. However, a replacement was put in place in 2003 by Heritage Engineering of Glasgow with the design based on the similar Sun Foundry bandstand on The Links in Nairn.

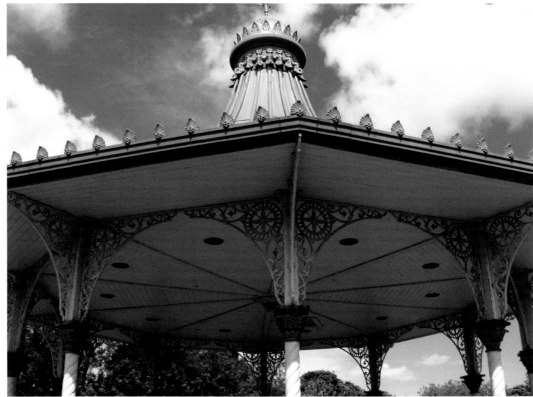

Leazes Park in 1910.

Barley-twist columns and centre and radial spandrels on this replica Sun Foundry bandstand in Leazes Park.

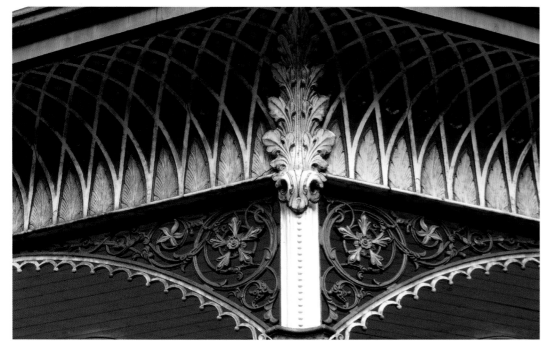

The detail on the bandstand in Exhibition Park is fine and certainly intricate.

Exhibition Park at the turn of the twentieth century.

Across the other side of the city is Exhibition Park, which was initially developed on land that was part of Newcastle Town Moor and known originally as Bull Park. Following the completion of Leazes Park in 1873, the site of Bull Park (which formerly housed the town bulls) was laid out during the 1880s. The land was appropriated from the freemen during the 1880s in preparation for the Mining Engineering and Industrial Exhibition, which was held in the royal jubilee year of 1887, and from which a bandstand has survived. After the first exhibition the land was used as a recreation ground until 1929 when the site was laid out in an art deco style for the North East Coast Exhibition. The trade fair was in aid of promoting north-east trade during an economic slump and the exhibition was housed in a large number of buildings designed for each category of exhibits. Over 400 exhibitors participated and 4.3 million visitors attended, making it the largest event ever held in Newcastle upon Tyne. The majority of the buildings were demolished in 1930 and the park name was changed from Bull Park to Exhibition Park.

The landscaping of Exhibition Park was an integral part of the design and followed principles established by landscape designers of the art deco period interested in geometric layouts with strong axial emphasis. This aesthetic was admirably suited to civic spaces as the long boulevards, canals, terraces, steps, linear hedges and lines of trees all added scale and drama to the civic buildings to which they provided a setting. The bandstand from the 1887 exhibition has survived in its original location and is one of the few remaining examples of a Model 225 from Walter MacFarlane's Saracen Foundry. Sadly, a similar excellent example from Alloa no longer exists but was described as a:

Stand of octagonal form … [which] rests upon a foundation of brick with stone coping and wood flooring, and rises to a height of about 32 feet, with a diameter of 24 feet 4 inches. It consists of massive ornamental cast-iron columns with spandrel shafts above capitals, from which spring decorated spandrel work forming arched bays between the columns. Rising above there is a handsomely figured coved cornicing, with antefixes, surmounted by a double curved dome shaped roof with a corona terminal. A railing of Italian character stretches between the base of the column … The ceiling is made of narrow tongue and grooved pitch pine boarding, the resonant nature of which makes a first-class sounding board. The whole structure will be painted and the salient parts picked out in gold and protected by a light spiked wrought-iron railing. Messrs Walter MacFarlane & Co. of the Saracen Foundry, Glasgow, are the designers and constructors of the stand.

SOUTH MARINE PARK, SOUTH SHIELDS

South Shields has been lucky enough to retain its two bandstands. Probably one of the most ornate and delicate of MacFarlane's bandstands was erected in South Marine Park in 1904 at a cost of £481 and stood on the lower part of the terrace with wonderful views over the North Sea. Declared unsafe in 1955, it was sadly lost along with the same models found in Calverley Park, Tunbridge Wells and Worthing seafront. The latter two were never replaced but incredibly, South Tyneside Council (with funding from the Heritage Lottery Fund) were able to replace the lost bandstand of South Marine Park. The challenge for restoration experts, Lost Art of Wigan was therefore to reproduce the original bandstand, based only on historic photographs. Their research identified the original maker of the bandstand as the MacFarlane Foundry and from this they were able to identify the original component pieces of the bandstand. Although the company produced many original bandstands, they often combined features between the different designs – a sort of Victorian pick and mix in cast iron. Having identified the components, the restoration experts were then able to reproduce patterns in order to cast the new components and replace this wonderful bandstand which once again overlooks the North Sea.

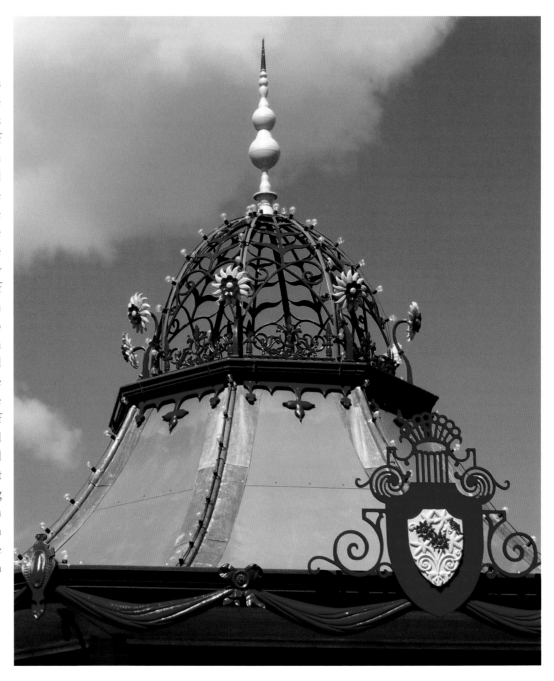

The dome and cresting on this replica MacFarlane bandstand in South Shields has been skilfully recreated by Lost Art from Wigan with a simple but imaginative colour scheme.

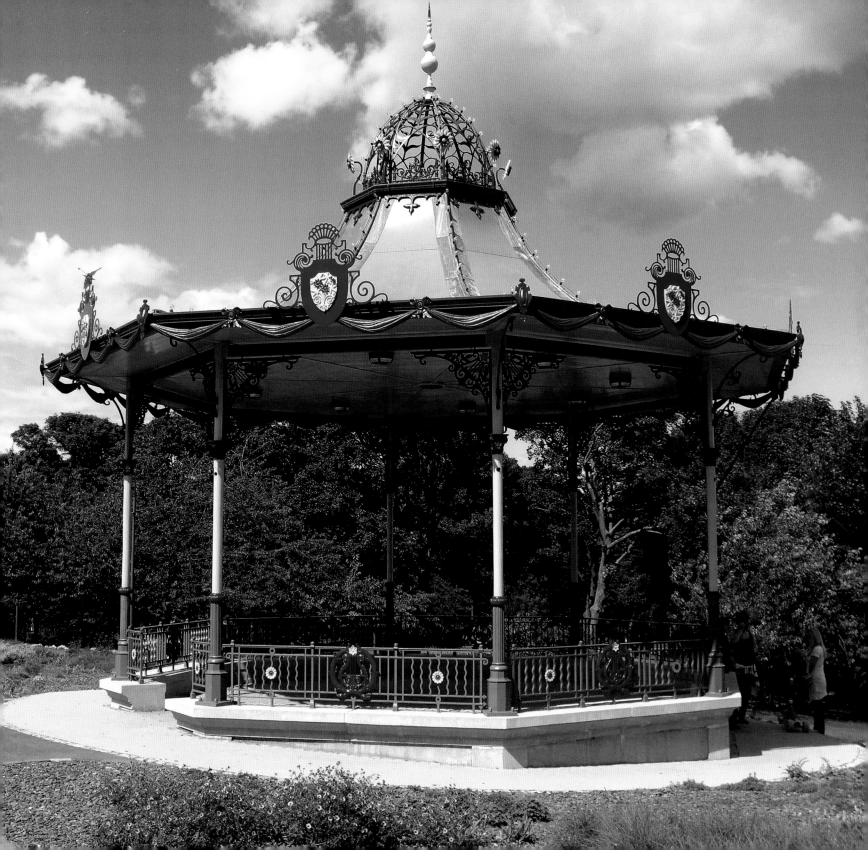

BARNES PARK, SUNDERLAND

Sunderland has retained all three of its bandstands, in Roker Park, Mowbray Gardens and Barnes Park. Barnes Park was laid out in the late nineteenth and early twentieth centuries and is the largest park in Sunderland. It is set in a picturesque valley through which the Bishopwearmouth Burn flows, and was bought in 1904 for £8,500. Only three years later, the laying out of the park was started and was especially important as it was when the depression of trade struck in 1907 – the project hence became an important source of employment for a number of 'practical gardeners' from the Sunderland area, with 2,798 men being employed on its construction. Barnes Park was ultimately opened in August 1909. Many of the already well-established trees were retained including oak, ash, beech and elm trees. Paths curved throughout the park in many directions. At the west side of the park, on the highest piece of ground, were established two bowling greens, tennis courts, and a cafe. When the park opened in 1909 the original bandstand was a painted timber structure, but this was later replaced by the cast-iron bandstand that exists today. This simple but quaint bandstand was designed and built by W.A. Baker and Son of Newport, Monmouthshire, and is an excellent example of a more restrained Edwardian style of bandstand. As part of the restoration project the bandstand was fully restored by Lost Art of Wigan, thankfully using the original blueprints that remained.

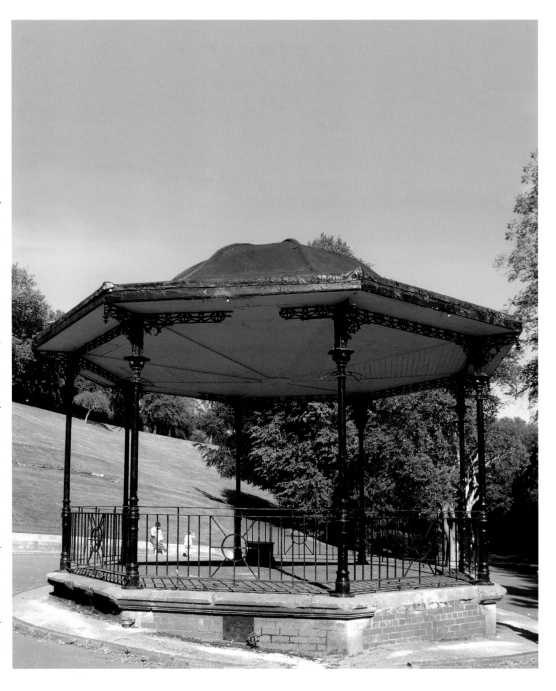

Barnes Park bandstand, pre-restoration and badly vandalised, in this popular Sunderland park.

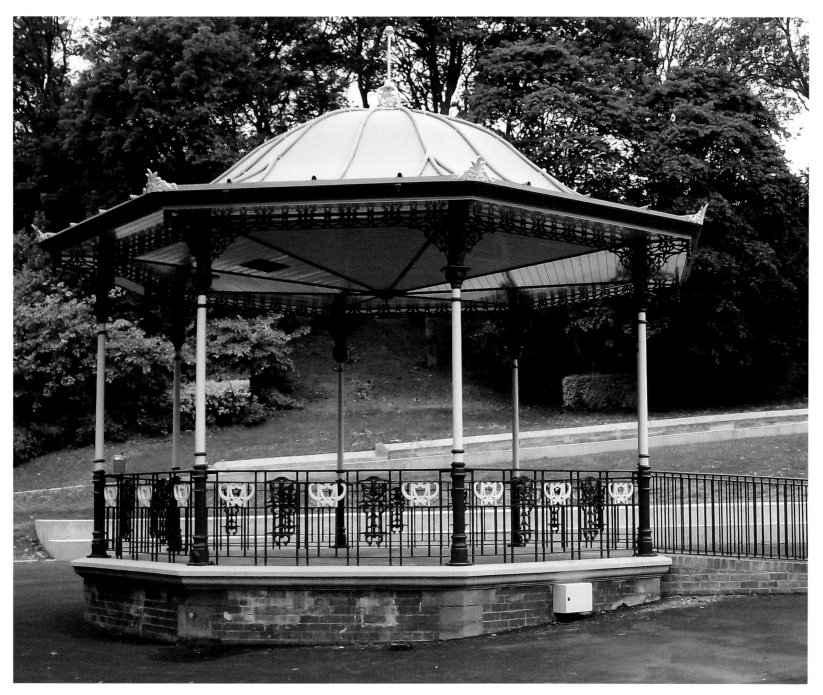

Restored as part of a wider restoration scheme for Barnes Park.

ALBERT PARK, MIDDLESBROUGH

Band music was popular in Albert Park from a very early date, when the park was opened in 1868. The Middlesbrough Police Band was probably the first to play in the park along with works' bands and military bands who entertained the crowds of visitors on summer outings. The original bandstand was erected in the summer of 1871, by George Smith & Co. Sun Foundry and an 1871 newspaper article describes how 'a beautiful octagonal iron stand for the band is approaching completion and is an ornament to the centre of the park, the light columns and elegant roof giving the structure quite an oriental aspect'. The bandstand was removed sometime during the 1950s but as part of the Heritage Lottery Fund approved restoration of Albert Park in 2003 (incidentally project managed by the author) it was decided to replace the original bandstand as part of the park's restoration.

All that remained were old images and no drawings of this bespoke bandstand. It was Heritage Engineering from Glasgow who pulled together a design for the replacement bandstand, including the baluster panels which are barely visible under the drapes shown in some of the rare images. The bandstand was then refabricated in a Scottish foundry as it would have been nearly 150 years ago in the original Sun Foundry. It was finally re-erected in 2005 and now hosts a range of events in Albert Park, including popular Sunday concerts.

The original bandstand in Albert Park, Middlesbrough.

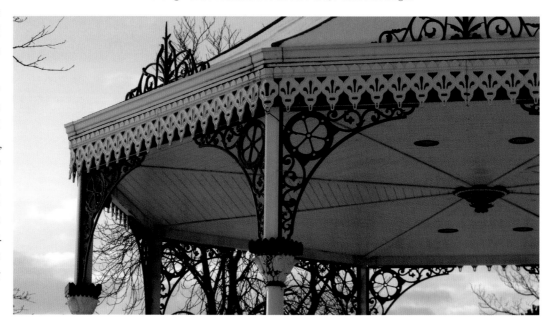

Intricate detailing on the replacement bandstand, which was reintroduced in 2005.

Like Sunderland, Darlington has retained its three original bandstands, rescuing all from virtual dereliction. Of the South Park bandstand (shown opposite), the local *North Star* reported in 4 July 1893: 'Tonight, the newly-erected bandstand at the public park will be opened … selections of music will be played by the combined bands of Darlington Volunteers and the Sons of Temperance, numbering nearly 50 performers.' The new MacFarlane 279 bandstand was opened where:

> An assemblage of between 2,000 to 3,000 had gathered by the bandstand which had only been approved some four months previously. The Chairman of the Parks Committee, on performing the opening ceremony, answered criticisms that the 'new and beautiful' bandstand was unnecessary and, at around £300, too expensive, by asserting that 'the old bandstand was most incongruous and there for the money they expended they had got a thing of beauty in itself with beautiful surroundings'.

The once-derelict bandstand in North Lodge Park has also been fully restored, an Edwardian stand from McDowall Steven & Co. and similar to models erected in Roker Park, Sunderland, as well as several lost bandstands in Leeds and Valentine Park in Ilford. A stunning restoration by Lost Art was entirely driven by the remarkable Yvonne Richardson from the Friends of North Lodge Park who raised the money and lobbied Darlington Borough Council to ensure a full restoration.

North Lodge Park bandstand with boathouse in the foreground.

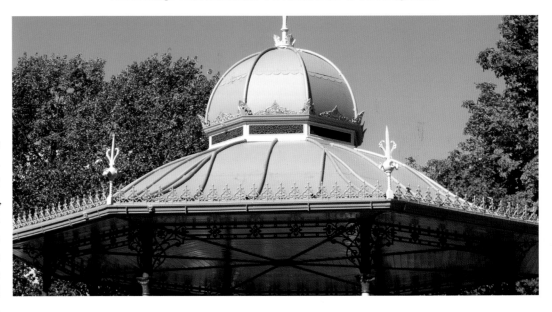

Above: A UFO landing in North Lodge Park?
Right: South Park bandstand, fully restored, thanks to lottery funding.

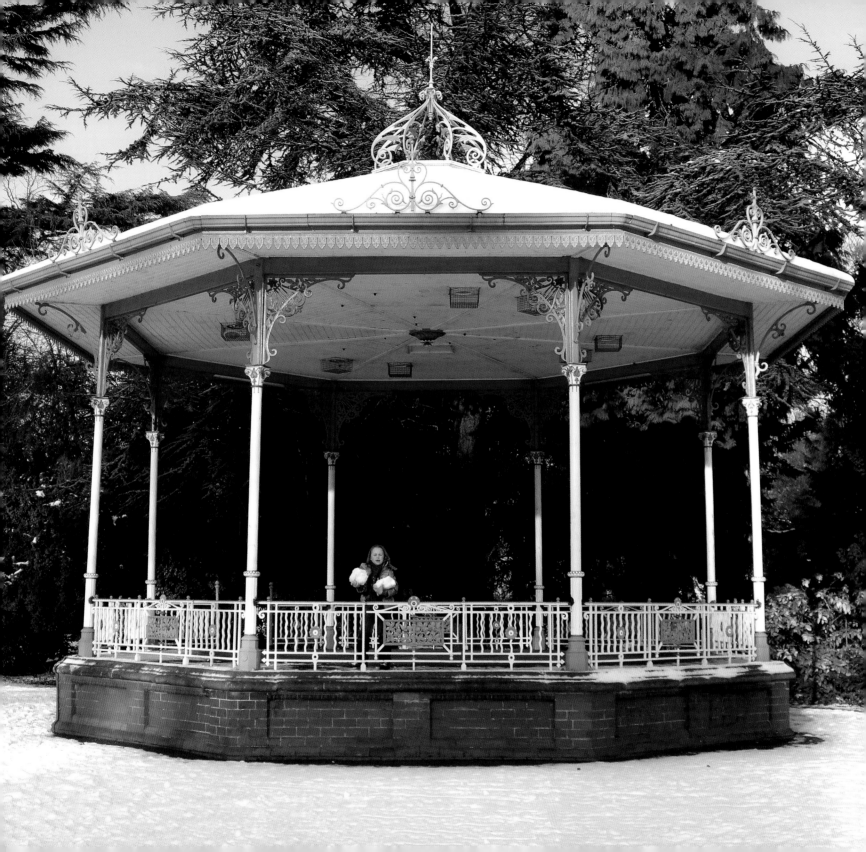

A more challenging project was the restoration of an extremely derelict bandstand in nearby North Park where no historic images remained and it wasn't even certain who the previous manufacturer was. It turned out to be a similar bandstand to one erected in Harehills Park, in Littleborough near Rochdale, which was once again a Walter MacFarlane bandstand. It could have quite easily been lost forever, after years of abuse, neglect and serious arson, but today sits in a popular neighbourhood park, loved and used once again.

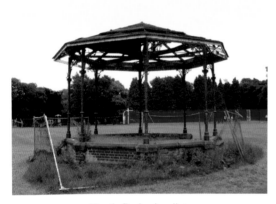

North Park, derelict.

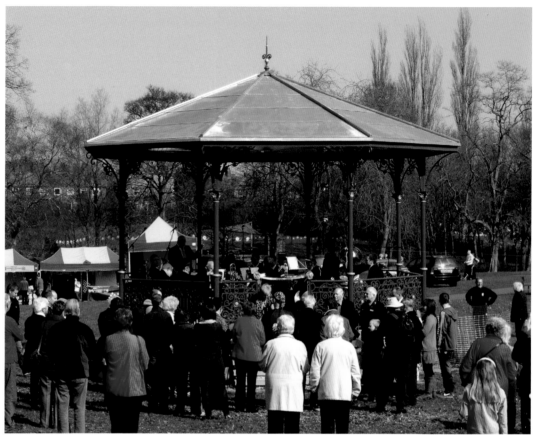

North Park, restored despite doubts over its history.

LINCOLN ARBORETUM, LINCOLN

Continuing with the increasing national trend of providing public parks, the Lincoln Commons Act of 1870 was passed and Monks Leys Common, to the east of Lincoln, was purchased by the corporation through an Act of Parliament. Permission was given to sell 3 acres of the land entirely for building homes and to assist with the funding of the design, layout and building of the Arboretum, which would eventually become Lincoln's first public park. Landscape gardener Edward Milner was employed in July 1870 by the corporation to initially inspect the new site and then develop a design. This design was carefully considered by the council and 'unanimously approved' on 13 September 1870. Work commenced immediately with a sum of £500 handed to the Arboretum Committee by the treasury. The new Arboretum was eventually opened in August 1872 and was attended by over 25,000 people. The many attractions included not only brass band recitals, but also Professor Renzo's Performing Dogs and Mr Emmanuel Jackson, the Midland aeronaut, in his new balloon. This most ornate of bandstands was erected on the large lawn in front of the terrace soon after in 1884, followed by an extremely busy programme of events including brass band concerts,

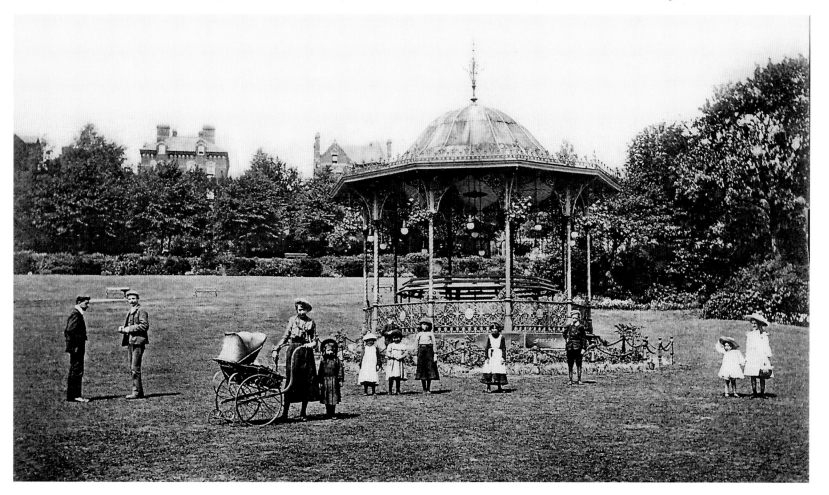

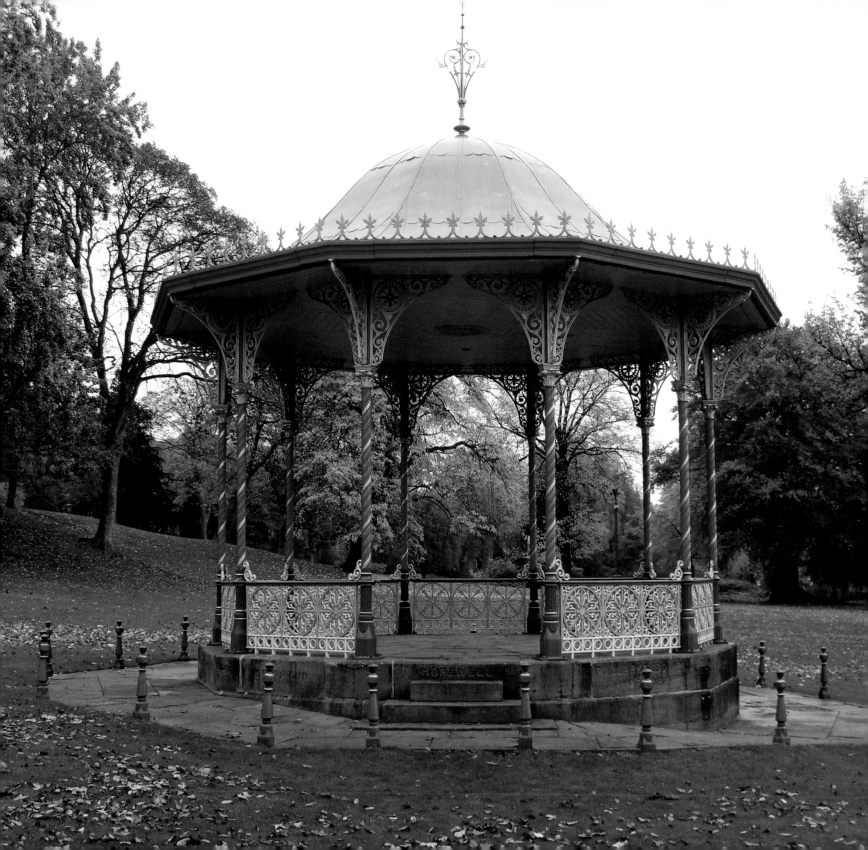

flower shows, fetes and galas. In 1889 over 40,000 people attended the band concerts alone.

The bandstand itself was sponsored by the Lincoln Lodges of Oddfellows and was installed at a cost of £120. The names of the lodges are engraved on the solid blocks of Bramley Fallstone that form the base. The initial donation of £25 was raised from the staging of a brass band contest which took place on a temporary wooden structure in the Arboretum. In April 1884 the corporation officially accepted the offer to supply a bandstand from the George Smith & Co. Sun Foundry of Glasgow for a price of no more than £175, with the opening ceremony taking place on 23 August. For once, the weather was benign, with the sun irradiating the metal regalia and the banners of the brass bands as they made their way along the familiar route of the High Street, Silver Street and Monks Road to be met by Mayor F.J. Clarke, sundry corporation officials and the secretary of the brass band contest committee. The secretary of the committee proclaimed, 'It is hoped that it will not only be an ornament to these grounds, but useful in inducing bands of musicians to discourse from its platform, music that has such power to soothe the savage breast, and enliven the hearts of visitors.' The mayor was fulsome in his praise, saying:

I think the brass band concerts are a great improvement on the 'so called' fetes that have been held in years past. There cannot, in my opinion, be a more sickening sight than to witness three or four painted brazen images in tights, dancing about on a raised platform in the broad light of heaven.

Around 10,000 visitors attended the opening and the evening culminated in the ubiquitous firework display. In subsequent years, many concerts and contests followed with a wide-ranging repertoire. Some of the contests occasioned great controversy and in 1887 the judge's decision aroused such animosity that the police were called in to protect him from being mobbed until he was able to escape to the railway station in a cab! Promenade concerts were a regular feature in the Arboretum until 1895. They were much enjoyed and appreciated, as letters to the *Lincolnshire Chronicle* witnessed. A working man wrote:

Whether these concerts are taken from a musical, social or even temperance view, they provide very pleasant evenings for working men and their wives, so that the wealthy who can have their afternoon concerts ought to subscribe largely for season tickets, by doing which they help to provide for cheap evening concerts for the working classes.

It was a combination of bad weather and poor afternoon attendances that finally brought the promenade seasons run by the city council to a close. The bandstand continued to be used well into the following century and in 1903 it was equipped with electric lights.

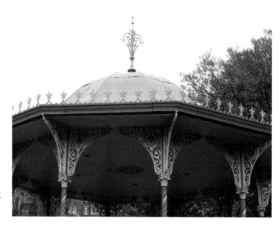
Cresting, spandrels and design unsurpassed in the Lincoln Arboretum bandstand.

During the 1940s, the Arboretum provided a welcome sanctuary from the rigours of the Second World War despite the removal of most of the perimeter railings from the grounds. Sunday evening band concerts attracted large audiences once again, and various other entertainments were provided in the government's 'Holidays at Home' scheme. The Arboretum and bandstand declined considerably during intervening years until the park was finally restored in 2002 with funding from the Heritage Lottery Fund. The bandstand had lost most of its baluster panels, which had been used on a nearby footbridge, and the chains which once protected the bandstand from abuse had long since gone. The paint had also chipped, ornamental sections had broken off and the zinc roof was coming loose. Restored by Eura Conservation, it was dismantled and restored in workshops off site and carefully reassembled on site. Concerts and performances in the park are once again very popular with locals and visitors, with the bandstand now sitting prominently in the Arboretum in all its glorious Victorian colours.

George Smith Sun Foundry, Glasgow.

CLIFTON PARK, ROTHERHAM

Clifton Park has seen two very different iterations of bandstands over the last 150 years. Clifton House itself was built in 1783 and was previously owned by the Walker family. They were early industrialists who were involved locally in the manufacture of iron and steel up until 1864. The house was then purchased by industrialist William Owen. Following his death in 1891, the Municipal Borough of Rotherham bought both Clifton House and the grounds and land for £25,000 and ultimately transformed it into a public park which was eventually opened to the residents of Rotherham on 25 June 1891 by His Majesty Edward VII, the Prince of Wales.

The council had begun looking at the possibility of providing music in Clifton Park and around 1894 the first bandstand was erected by them. Bands were certainly popular in Clifton Park during the late 1890s, and continued right through to the 1980s. This bandstand also had

glass windows complete with sliding doors, like many of the time, but these too were sadly removed due to vandalism in the park. A First World War tank was then placed on the former site between 1919 and 1927. A temporary bandstand was 'To be erected' in May 1922, but does not appear on any Ordnance Survey map. However, a new 'concrete temple with classical columns' bandstand was erected on the site of the old bandstand, was opened in May 1928 and remains to the present day. The *Rotherham Advertiser* reported in June 1930 that the Clifton Park band performances were attracting large crowds but complained about the numbers who:

Immaculately attired, passed by (the entrances) without contributing to the collection sheets … at least a humble copper. Admittedly, there is no legal obligation, but there is a moral one, and, knowing the characteristic generosity of Rotherham residents … we cannot feel that the individuals who came under our notice hailed from, shall we say, Leeds, Leith or Llanfairfechan.

The bandstand was renovated and reopened by Queen Elizabeth II in May 1991 and then further restored in 2009 as a result of the Heritage Lottery Fund restoration programme. It is now one of the finest bandstands in the region.

The original bandstand in Clifton Park, Rotherham.

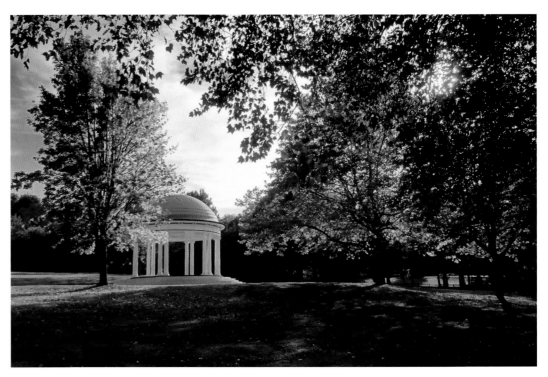

The ionic temple 'bandstand' in restored Clifton Park.

LEEDS AND BIRMINGHAM

Like most towns and cities, the mania for the building and laying out of parks was from the middle of the nineteenth century to the beginning of the Second World War. In particular, cities such as Manchester, Leeds, Birmingham, Sheffield and Liverpool were at the forefront of such initiatives. Many of these parks and recreation grounds included bandstands from an early stage, but two cities stand out for different reasons – Leeds and Birmingham.

As local councils eventually acquired the authority to face some of the major urban problems, so their self-assurance grew and with it came an increased sense of civic awareness. These changes in attitude were seen vividly in that most civically conscious of towns, Birmingham. Joseph Chamberlain brought a revolution in Birmingham's Council Chamber and in attitudes towards the major problems. The result

was improvement on an unprecedented scale. Birmingham was not the first or the only urban centre to initiate municipal improvements but it was probably the most vocal. Birmingham obtained its first parks by leasing them and in 1845 funds were raised for public walks, but were used instead to pay for public baths. Early parks include Adderley Park (1856) and Calthorpe Park (1857), Aston Hall Park (1858). Others followed with Cannon Hill Park (1873), Highgate Park (1876), and Summerfield Park (1876), Small Heath Park (1879), Handsworth Park (1882) as well as Lightwoods Park in Smethwick (1902) and Kings Heath Park in 1908.

In Leeds, the mayor speaking in 1871 advocated the purchase of Roundhay Park to the council for the pride and status that would accrue: 'If they got Roundhay Park, it would be as great a credit to them as their town hall. It would give them a

status in a way that few things would.' As Leeds had expanded, its unenclosed commonland, Woodhouse Moor, Hunslet Moor and Holbeck Moor, had come under increasing pressure. New parks appeared at Woodhouse Moor (1857), Bank Lodge Recreation Ground (1869), Bramley Recreation Ground (1870), Roundhay Park (1872), Woodhouse Ridge (1876), Holbeck Intake (1877), Hunslet Moor and Oak Road Recreation Ground (1879) and New Wortley Recreation Ground (1884).

In both cities, bandstands were erected in most of these parks as part of the growing movement and the demand for music and entertainment therein. However, what stands out is that whilst Birmingham has retained many of its bandstands, Leeds has lost all but one of its eighteen.

THE LOST BANDSTANDS OF LEEDS

One of the earliest of Leeds' parks is Cross Flatts, at 44 acres and opened in 1891, it had an impressive McDowall Steven & Co. bandstand erected soon after in August 1899. The bandstand was a large and ornate structure, set on a raised dais. The actual floor of the bandstand had a low cast-iron balustrade around its perimeter.

Bramley Park was laid out, planted and opened in 1872 and another MacFarlane bandstand was central to its layout. Crowds regularly gathered to attend brass band concerts here with seating arranged in a circle around this ornate bandstand.

In 1886 the then owner of Osmondthorpe Hall, John Robinson, sold 50 acres of the grounds to the council so that a park could be provided for the residents of east Leeds. East End Park was bought with the land acquired as pit wasteland. The council created the park on it with a lake that was created artificially, using the existing natural topography. This also included the impressive MacFarlane bandstand at the turn of the century, similar to the bandstand found in South Marine Park in South Shields.

The most popular and well-known park in Leeds was Roundhay Park, which came into the

ownership of the Leeds Corporation in 1871. However, being so distant from the city centre and not having a reasonable public transport system at the time, it took off much slower than anticipated, with some debating that it was nothing but a white elephant. However, improvements were at hand with the introduction of the tramway system in 1891, and especially the first electric tramway operating on the overhead wire system in Europe. As a result the park soon established itself as a popular local visitor attraction for the masses within Leeds and surrounding area. It had previously been listed for auction after disputes over the will of its

former owner William Nicholson. However, since it was over 3 miles from the city centre of Leeds, the council were prevented from spending more than £50,000 on any one item. A specific Act of Parliament would be needed to allow this, which there was insufficient time to acquire prior to the auction. It was left to Mayor John Barran and a group of associates to bid for the land on behalf of the people and eventually obtained it for £139,000, selling it to the council for the same price once the required permission had been granted. Like in many of Leeds' other parks, a bandstand was soon introduced.

Roundhay Park's bandstand was octagonal in shape and was located between Middle Walk and Carriage Drive and was overlooked by the nearby mansion. It was distinctive for its decorative, wrought-iron spire above a cupola and dome.

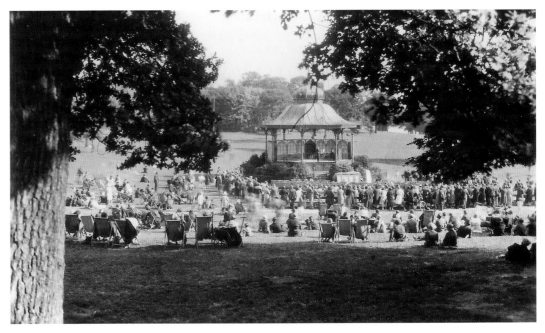

Roundhay Park, Leeds.

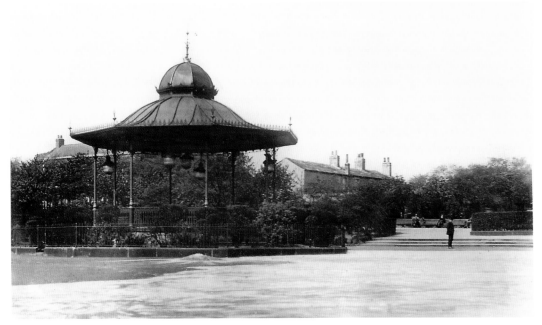

Cross Flatts Park, Leeds.

This particular bandstand was raised to give a better view to crowds, who gathered in large numbers to listen to the frequent concerts given every Sunday. This raised construction permitted deckchair storage beneath it. Like many others, it fell into a poor state of disrepair and was taken down in the early 1960s.

Local people recall going with their parents to hear Welsh crooner Donald Peers, when women would swoon to the strains of his songs in particular 'In a Shady Nook by a Babbling Brook. That's where I fell in love with you'. 'His fans were in the hundreds of thousands and there was a kind of subdued mania. He also had a rather distinct trademark: in concert, whenever he announced that he was about to sing his last song, there would always be a loud resounding "Aaaaaawwww" from all the ladies in the audience.'

Dartmouth Park is another Leeds park where views exist, showing a bandstand and several flower beds. Lord Dartmouth opened it on 27 May 1890. He donated the land to the borough and it was the first of Morley's public parks to be laid out. Sadly the bandstand blew down in a gale in 1962.

Another was Chapeltown Recreation Ground which covered an area of between 6 and 7 acres. It was purchased by the council in 1897 and was opened in a special ceremony which was held on 2 July 1900 and presided over by the Lord Mayor of Leeds, Alderman John Gordon. It was in the early

years that the committee decided to reorganise this space so as to ensure more grassed areas were available for children to play, hence reducing the size of the former ornamental gardens. A bowling green and cricket ground were also eventually laid out. As with many of the other parks and

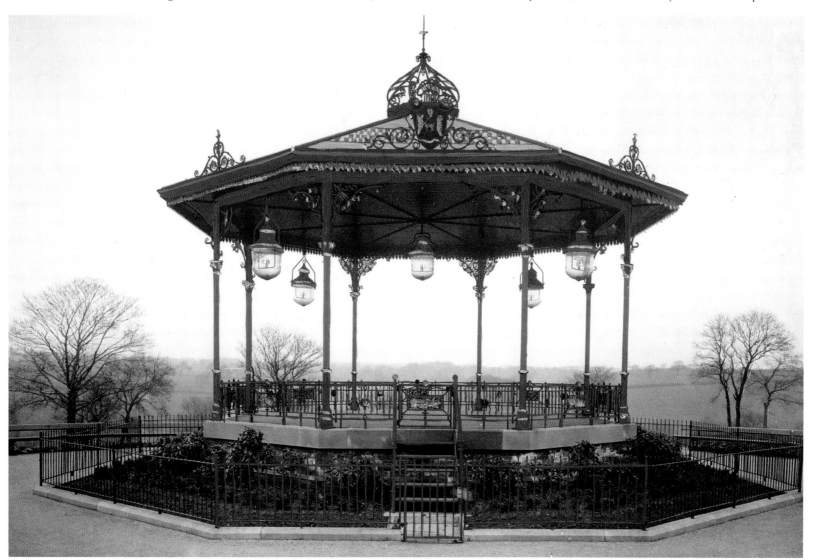

Chapeltown Recreation Ground.

recreation grounds in Leeds, it came with an impressive bandstand, this time another Walter MacFarlane but the more popular No. 279 model.

North Street Recreation Ground (now called Lovell Park) was previously the site of the Smithfield cattle market, which was closed in 1886. The area was ultimately landscaped and opened as a popular and much-needed public park in 1888 with another McDowall Steven & Co. bandstand, central to the park. Burley Park was acquired by the council in 1899. The park itself, built on over 14 acres of land, was opened in 1900 with this bandstand erected in 1906 after designs submitted by the Scottish foundry of McDowall Steven & Co., clearly popular in Leeds' parks.

Rodley Park was another Leeds recreation ground that was laid out and covered an area of 9 acres, which was purchased for the princely sum of £1,400. The Mayor of Leeds, Alderman John Ward Esq. this time performed the opening ceremony which was held on the 26 October 1889. Locally this was much looked forward to and became quite an event as £42 had been raised by local subscription to pay for fireworks, street decorations, as well as bands of music (on this occasion, the Calverley and Stanningley Brass Bands) as well as the provision of a free tea for all the schoolchildren of Rodley. At either end of the village, triumphal arches were erected which displayed welcoming messages for the Mayor and Mayoress of Leeds as they arrived along with many other organisations. The bandstand itself was located at the foot of the hill with an ornamental shelter situated nearby. Octagonal in shape, it was built on a base constructed of brick, with eight supporting columns for the roof, all decorated beautifully with wrought iron.

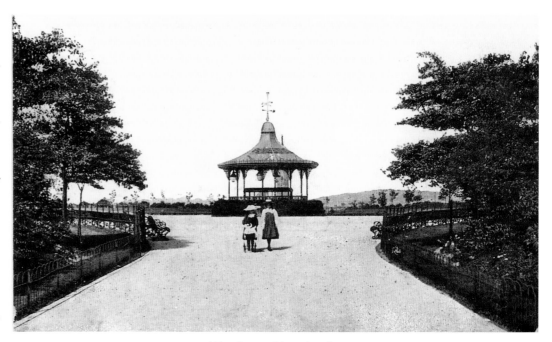

Woodhouse Moor, Leeds.

In 1885, Leeds Corporation purchased Woodhouse Moor for £3,000. It had always been an intended common, but was eventually laid out as a recreational area again funded with local public subscriptions which went towards a fountain, bandstand and ultimately a cricket ground, bowling green, aviary, and gymnasium. Since 1856 a band had often played on Woodhouse Moor throughout the summer months every Sunday and nearly always attracted a more than enthusiastic audience. Alderman William North in 1879 eventually presented the rather grand bandstand, which was entirely different to many of the others present in Leeds parks. A popular park, the principal walks were lit in the evenings by the lamps suspended from the centre of the ornamental arches.

Middleton Park has been one of Leeds' many public parks since 1919. A bandstand was constructed here in 1924 through subscriptions from local bands but was demolished in the 1950s. Another park was Wharfe Meadows Park, in nearby Otley, which was also opened in 1924, where bandstand concerts were held every Sunday afternoon as well as evenings.

In 1902, a 22-acre park was purchased by Leeds Corporation from the Cliff family who owned the nearby Cliff House and which became Western Flatts Park in Wortley. The house itself was gifted to the corporation later in 1928 and the park was extended further. Works involved removing large hills of rubbish as well as levelling large areas of the ground. Walks were laid out by the locally unemployed as was common at the time and which included a number of facilities for open-air games, such as a newly constructed bowling green. Eventually, a raised bandstand

was erected and for the many visitors who were to enjoy evening and Sunday concerts, a circular arrangement of seating was provided.

Wortley Recreation Ground was laid out in 1905 with a very grand Walter MacFarlane No. 249 erected on an impressive plinth with storage beneath it.

On Woodhouse Ridge, band concerts were popular on this exposed area but with magnificent views too. The bandstand, this time from the West Midlands foundry of Hill & Smith, was erected certainly before 1905.

Armley Park is often locally called Gott's Park, named after the well-known Leeds industrialist Benjamin Gott who not only was born and lived in Armley, but died and was eventually buried there. In 1799 Gott became Mayor of Leeds, and was extremely wealthy by the time he died in 1841. Overlooking the Kirkstall Valley and the Leeds and Liverpool Canal from the Armley side, Gott's house was built in 1820 with landscaped grounds designed by none other than Humphry Repton. By 1928 Leeds City Council had leased Gott's house and grounds in order to create a municipal golf course and eventually the new Armley Park. Not far from the main central entrance is the ornamental fountain commemorating Queen Victoria's diamond jubilee which was presented to the park by W.H. Gott Esq. of Armley House. In the centre of Armley Park

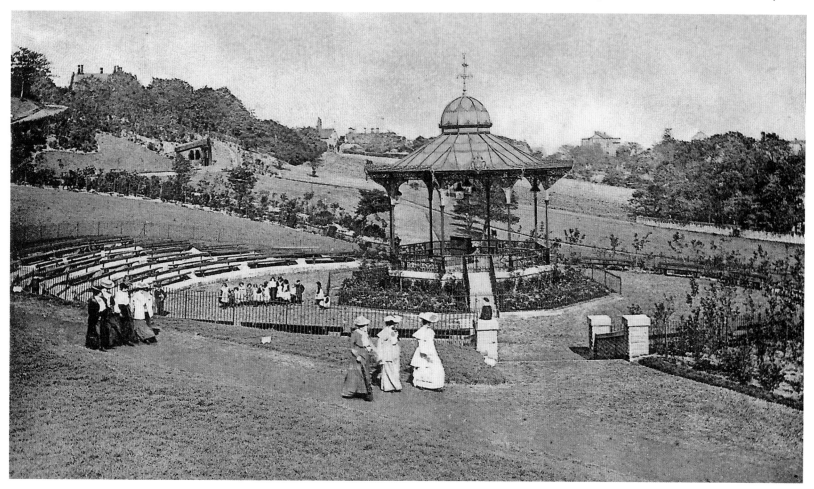

Western Flatts Park, Leeds.

was, however, the bandstand which was donated by the overseers of Armley. At either side of the bandstand were two covered shelters. One of these shelters was for designated use of ladies and children only and can safely assume the other was for gentlemen. Dancing on roller skates to music around this bandstand in the 1920s was popular. It was also a popular meeting place for young people at that time.

But what of the only remaining bandstand in Leeds? The timber but almost rustic design of the bandstand in Horsforth Hall Park is the sole survivor and the irony is that it has outlived the cast-iron and ornamental nature of its predecessors. It still hosts summer band concerts as it has done throughout its history and has been the focus of many events including the coronation celebrations in 1953.

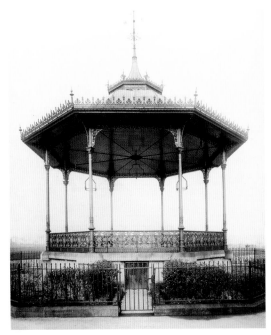

Wortley Recreation Ground, Leeds.

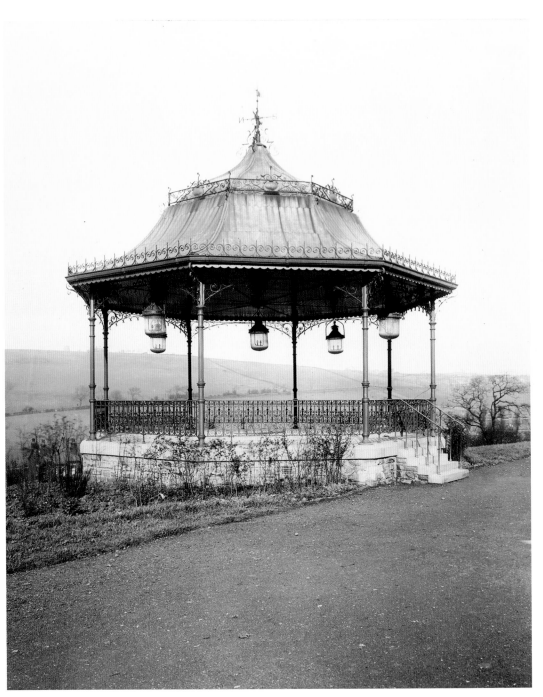

Above: Woodhouse Ridge, Leeds. Right: Armley Park, Leeds.

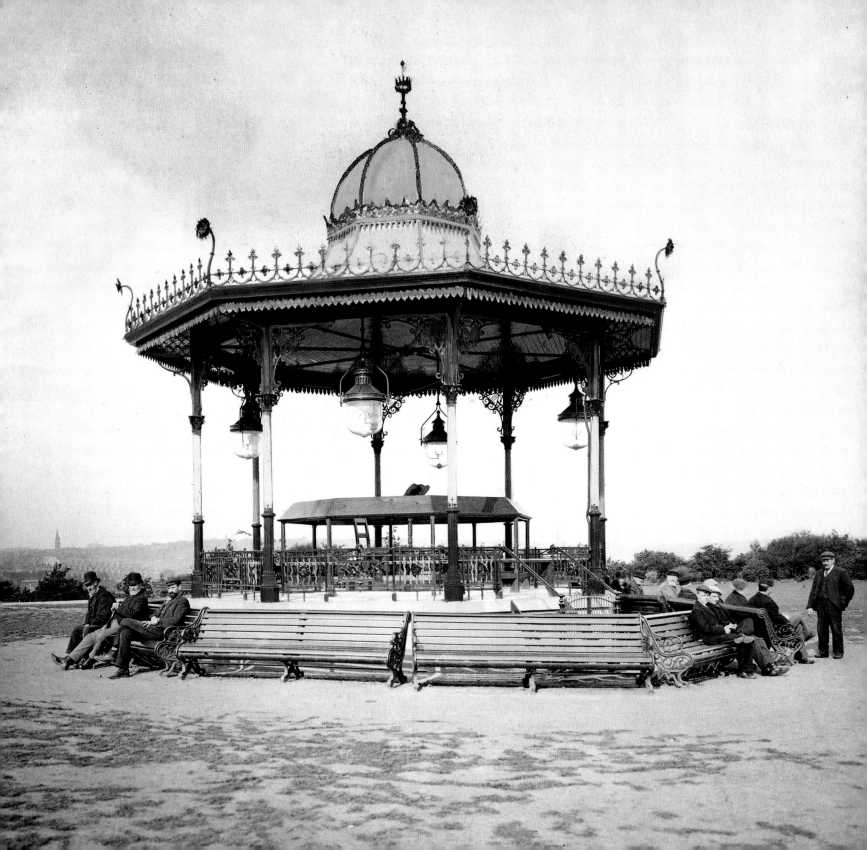

Victoria Park (or Handsworth Park) was largely created in two parts, the first part opening on 20 June 1888 and the second was added much later in 1895. During its early years, the land for the park was acquired section by section. Despite this rather disjointed and piecemeal approach, the landscape does have a wonderful unity of design and is certainly an indication of the quality of the plans prepared for the first 20 acres by R.H. Vertegans and executed under the direction of the borough surveyor,

Edwin Kenworthy. The park consisted of an old pond, which had been converted into 'a small ornamental water, a number of pretty walks' and 'a fine broad promenade 700 feet in length'. The eastern side of the park incorporated a fine boating pool. The lake was used for fishing, boating and ice skating in winter and eventually a fine Lion Foundry of Kirkintillock bandstand was erected in 1903, which was a focal point on Wednesday and Saturday evenings when large crowds gathered to listen to various bands.

From the 1970s Handsworth Park, like many across the country, was increasingly neglected with the condition of the once popular but then derelict bandstand a reflection of the condition of the park, with baluster panels missing and the roof in poor condition. Once again, a stunning restoration was carried out in 2005 by Heritage Engineering under the design and supervision of Hilary Taylor Associates with a colour scheme unlike any other seen elsewhere.

After the initial early activity of the late 1850s, there was a long period of stagnation in the parks movement in Birmingham. The first impetus towards any rejuvenated activity was instigated by Miss Louisa Anne Ryland, the representative of a well-known and much-admired Birmingham family who had generously contributed financially towards the purchase of nearby Aston Park. In 1873 Miss Louisa Ann Ryland generously gave to the town the estate of approximately 57 acres – then known as Cannon Hill Fields – in Moseley, which now forms the larger part of Cannon Hill Park. The following year, during his reign as Mayor of Birmingham, Joseph Chamberlain oversaw the expansion of the city's parks from 91 acres to 215 acres, making a significant impact on the environment. Before its presentation to the town the ground consisted of a series of meadows, but Miss Ryland, at her own expense, arranged for it to be drained, laid out and planted to make it suitable as a park. The park was opened on 1 September 1873 without public ceremony by the wishes of the donor. It was several years later before the impressive and unusual bandstand

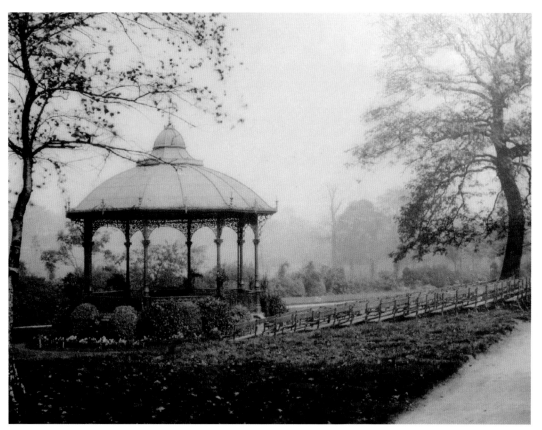

Handsworth Park, Birmingham

was to appear. The city council minutes for 1894/95 refer to the acceptance of a tender of £250 from Messrs. Hart, Son, Peard and Co. for the supply of a new bandstand and bell turret in Cannon Hill Park. Now a Grade II listed structure, it was beautifully restored in 2012.

The land for Small Heath Park was also donated in 1876 by Louisa Anne Ryland. Formerly a farm, it was expensive to adapt to ornamental use and Miss Ryland gave £4,000 towards the cost. The park was then opened on 5 April 1879, which was marked with celebrations locally. In 1887 the bandstand was added and it quickly became a focal point for communal entertainment, as were all the bandstands in Birmingham's parks at that time. During the interwar years many of them were used by the Police Band and for concert parties as well as Punch and Judy shows; whilst local bands and choirs were allowed free use of bandstands

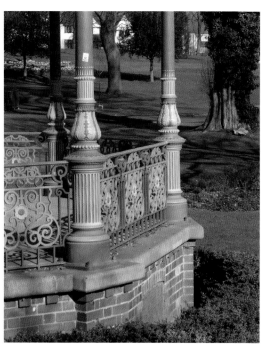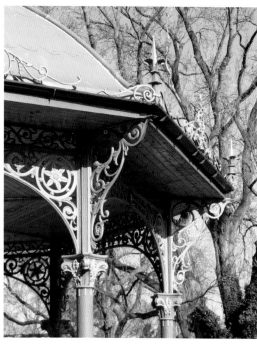

Handsworth Park, Birmingham, restored after a major park regeneration project.

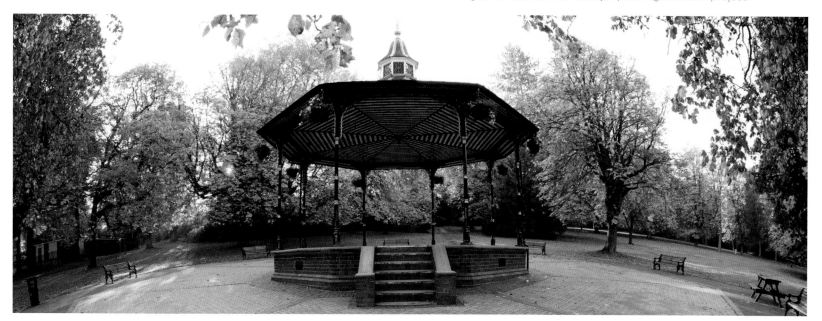

Cannon Hill Park bandstand, restored after years of neglect.

as long as they made their own arrangements for ticketing and stewarding. However, sadly many of the Birmingham bandstands later fell out of use and a number disappeared including Calthorpe Park, Kings Heath Park and Warley Woods. But not all were lost as with Leeds. Small Heath Park's unique and extremely unusual bandstand remains.

This park has a quaint history. On Wednesday, 23 March 1887, Queen Victoria went to the park during her visit to Birmingham. It was her golden jubilee year and thousands cheered her, according to reports that appeared in many newspapers across the country. To honour her visit, the mayor asked for permission to change the name of Small Heath Park to Victoria Park. This was, of course, granted, although local people have continued to call it by its original name of Small Heath Park. Since its opening, Small Heath Park has served as an invaluable facility in a district that has changed dramatically in its demographics. It remains a much-appreciated feature but there is still a real need to bring back into use many of its features that have been neglected or closed and the Friends of Small Heath Park are working tirelessly to achieve this. Foremost amongst these features is its bandstand, which is still one of the oldest surviving bandstands in the country and which is of a unique type with a double line of columns. Its condition in 2014 is still poor and it is in dire need of restoration.

Lightwoods Park is another popular Birmingham park with an impressive surviving bandstand. Lightwoods House took its name from the tract of woodland in the area and it was leased to George Caleb Adkins in 1858, who was a local soap manufacturer. He bought the house including land in 1865 and lived there until he died in 1887. In 1902 Lightwoods House, with its 16-acre park, was put up for sale. It was expected that the house would be ultimately demolished and the land used for building housing. However, it was primarily through the efforts of local industrialist A.M. Chance that the house and park were purchased for use by local people. By October 1902, the committee which had managed and successfully raised the purchase money, handed over Lightwoods House and the parkland to Birmingham Corporation with the latter to be used as a public park. But it is the bandstand that dominates this popular Smethwick park, the same Lion Foundry model as seen in nearby Handsworth Park. A plaque on the bandstand announces: 'This bandstand was presented to the city of Birmingham by Rowland Mason Esq. J.P. West Mount Edgbaston Erected April 1908.'

The history of the Lion Foundry itself is fascinating as in 1880 three staff from the hugely successful Saracen Foundry of Walter MacFarlane left the company and set up a business in Kirkintilloch near Glasgow. James Brown had

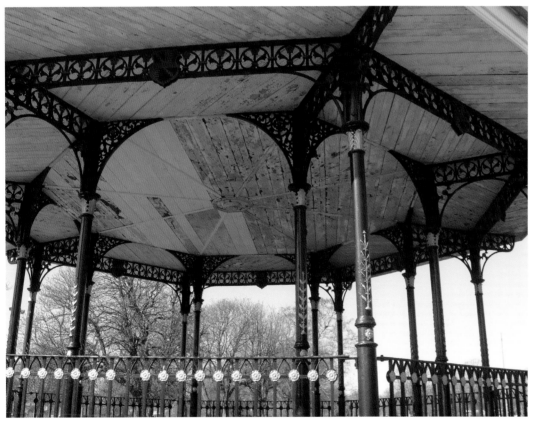

Small Heath Park, Birmingham.

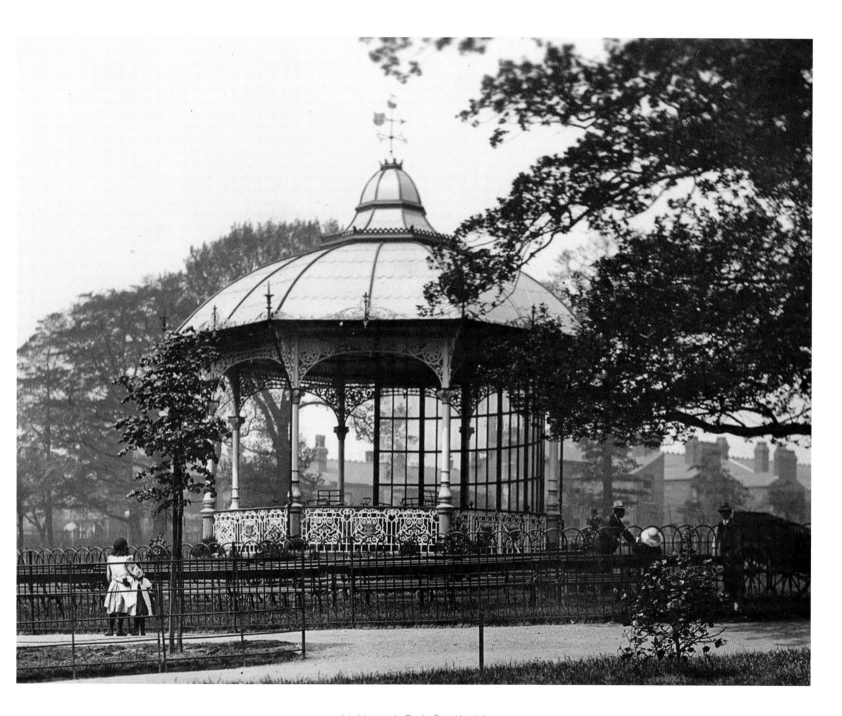

Lightwoods Park, Smethwick.

been a clerk in the order department at Saracen, James Jackson a salesman and Robert Husdon a fitter. The following year William Cassells, who had been a designer and draughtsman at Saracen, left to take up the same post with them: the design references are apparent in the work from the point Cassells joined. He was succeeded by James Leitch, who was responsible for many of the art nouveau designs produced by the company. Originally known as Jackson, Brown, Husdon & Cuthbert, the company changed its names to the Lion Foundry in 1885. In 1893 the company became a limited liability company with the formation of the Lion Foundry Company Ltd. Like its competitors and local contemporaries, Lion Foundry produced ornamental cast ironwork, including railings, crestings and terminals in its early days, but it quickly started to manufacture fountains, bandstands, canopies and larger structures. It also produced pattern books, which grew larger as the company developed. Significantly, the Lion Foundry outlasted Walter MacFarlane & Co. by twenty years, surviving in Kirkintilloch until closure in 1984.

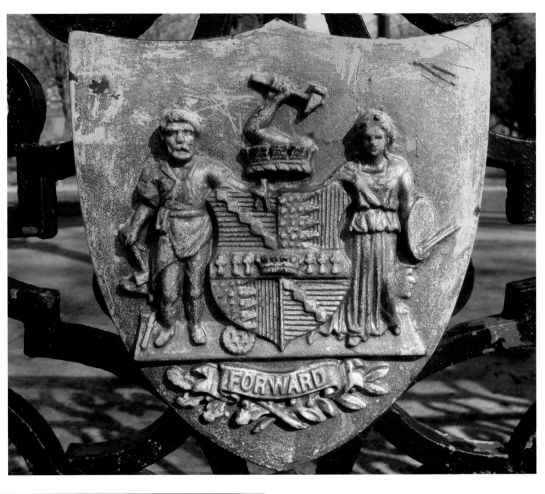

Along with those in Birmingham, throughout the West Midlands many other fine bandstands have survived, including Walsall, Wolverhampton, and Stourbridge. Many of these have been restored and have a new lease of life with some fine restorations by a new breed of fabricators such as Lost Art, Heritage Engineering and Eura Conservation.

MARY STEVENS PARK, STOURBRIDGE

This park was given in memory of my wife, Mary Stevens, a noble woman who went about doing good: to be for all time a place of rest for the weary, of happiness for children and beauty for everyone.

(Ernest Stevens at the opening of the park 6 April 1931)

Ernest Stevens was an extremely wealthy and prosperous industrialist who was born in Lye in 1867 with his philanthropy benefitting so many and especially the people of Stourbridge and its surrounding areas. He purchased the Studley Court Estate and other lands from the nuns of the St Andrews Convent and others for £15,257

and presented it to the borough as a public park and recreation ground, to perpetuate the memory of his late wife. The park is named after Mary Stevens, a Victorian woman who was partly driven by personal experience (having lost a baby daughter and 20-year-old son) to improve the lives of young women and children in the area.

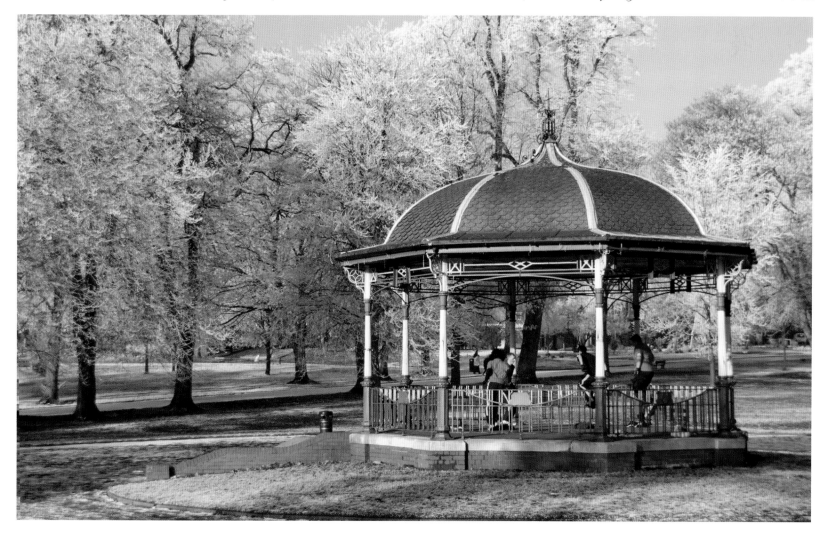

She had the idea of creating an Infant Welfare Centre which was eventually opened in 1916.

During this time the land donated by Ernest Stevens was transformed by the designs of Borough Surveyor Frederick Woodward, with the construction of paths, a bowling green, croquet lawn and tennis courts, a landing edge to Heath Pool for rowing boats, a terrace area to the rear of Studley Court laid out with formal gardens, the installation of a bandstand and a formal boulevard through the centre of the park – later to be named Queen's Drive after the royal visit of 1957.

This lovely bandstand is made of cast iron and was manufactured locally by Hill & Smith Ltd of Brierley Hill in the West Midlands (near Dudley). It is of the same model as found in Rockingham Road Park, Kettering. Hill & Smith is still in operation today and now specialises in motorway barriers. Designs for the park bandstand were presented before the council in July 1930 and a vote decided upon the more elaborate and expensive design. The design of the bandstand is, however, fairly standardised and chosen from a catalogue, though individual specifications may have been requested, such as the materials for its roof.

Early pictures of the park indicate that the bandstand also contained a number of glass panels located inside the cast-iron supports as early as 1931. A narrow ring of iron on the roof of the bandstand may be the only remnant of these glass panels and may have been the method of securing the panels to the frame. Again, this was not unusual and was common on many bandstands of the period. The existence of the glass panels within the bandstand is confirmed by a report in the Stourbridge Improvements Committee Minutes from 12 July 1944:

> A Report was received from the Police that on the 15th June three youths were found near to the Band Stand in Mary Stevens Park, Stourbridge, shooting stones from a catapult. A pane of glass in the Bandstand was found to be smashed but there was no specific evidence that the youths had caused the damage. The Town Clerk advised that in the absence of evidence that the youths actually broke the glass, proceedings would be futile.

Other bandstands in Stourbridge include the impressive Lion Foundry model in Stevens Park in Quarry Bank erected in 1925. Another existed in the Promenade Gardens (now Greenfield Gardens). Originally an area of land called Burnt Oak, it was donated to the town by Walter Jones, owner of Jones and Attwood, makers of domestic and industrial heating systems and the first chairman of Stourbridge Urban District Council from 1894–98. The gardens were laid out in 1903 and included a most impressive bandstand. Sadly, the gardens soon fell into disrepair.

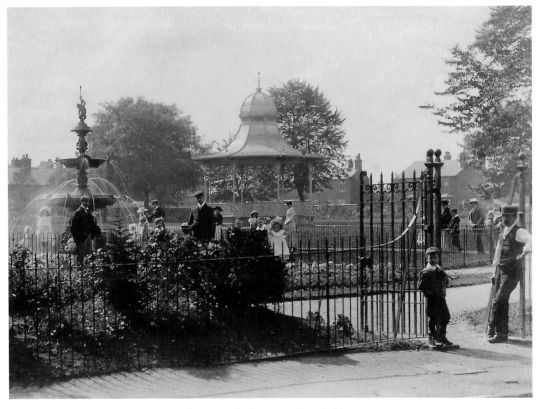

Promenade Gardens, Stourbridge.

THE ARBORETUM, WALSALL

Walsall Arboretum was originally laid out around two flooded limestone quarries and became an informal area for recreation before its official opening in 1874. At this time it was managed by the Walsall Arboretum and Lake Company as a private park with an admission fee. The council took over ownership of the park in 1881 and another opening event was held in 1884 for 'the first people's park'. The park was later extended in phases to the current layout comprising of about 182 acres. The formal historic core of the park houses several features including a Grade 2 listed boathouse, the locally listed clock tower, the lakes, a bandstand and the Leckie Sons of Rest building – the original pavilion refreshment room for the park.

The first bandstand opened in 1873; however, this was replaced by the bandstand which stands in the park today. The borough surveyor submitted designs for a shell bandstand as early as 1914 with dancing near to the original in 1916. By 1919 a scheme for a bandstand enclosure on the hill facing the present bandstand was approved, along with the removal of poplars and plans

The shell bandstand in Walsall Arboretum, a MacFarlane speciality ... apparently!

to 'inspect modern bandstands at Birmingham and Leamington Spa'. This shell bandstand was constructed eventually in 1924 and built by Walter MacFarlane & Co. at a cost of £1,550. It is the only example of a shell bandstand that exists as constructed by MacFarlane, which was unusual as one of his many adverts stated 'Shell Bandstands a Speciality'. The design is a stage with a curving roof supported by single cast-iron pillars and, at the two front wings of the stage, by pairs of columns joined above the capitals by a decorative plaque and surmounted with urns. It was significantly restored in 2012 with a stunning colour scheme designed by Hilary Taylor Associates.

WEST PARK, WOLVERHAMPTON

The first of Wolverhampton's large parks, West Park, or the 'People's Park' as it was then known, was opened by Mayor John Jones on 6 June 1881. The chosen site for the park was the racecourse, (or Broad Meadows) owned by the Duke of Cleveland. On 12 March 1879, landscape gardeners were invited by Alderman Samuel Dickinson to compete for the layout of the interior of the park, with a £50 prize to the winner. The winner was R.H. Vertegans of Edgbaston, who was instructed to include ornamental lakes to cover 8 acres, and up to 12 acres for sites for volunteer drill, archery, cricket and bowls. Central to West Park was this unusual bandstand which was presented by the Right Honourable Charles Pelham Villiers on 29 May 1882.

Wolverhampton's West Park and the Quarry at Shrewsbury both still retain their cast-iron bandstands by McDowall Steven & Co. of London and Glasgow, whose Milton Foundry was in Glasgow. The design of these two bandstands is unique amongst British bandstands, for its double circle of columns. This stand was evidently too small for later in the century the roof was removed and the bandstand was extended to this incredibly attractive design described by English Heritage as a 'cast iron ... octagonal [with] ogee roof surmounted with a weather vane. Eight plain outer pillars and eight inner barleytwist pillars with wrought iron railings and steps.'

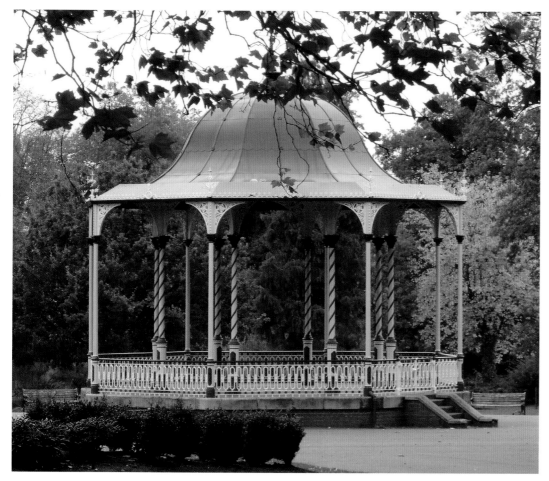

West Park, Wolverhampton, a McDowall Steven & Co. Ltd bandstand with a double row of barley-twist columns.

VICTORIA PARK, DENTON

Unlike Leeds, other areas in the north of England – including Bradford, Halifax, Rochdale, Liverpool and Manchester – managed to retain many of their bandstands. Tameside has retained two wonderful structures in both Hyde and Denton.

Over the years, the bandstand in Denton's Victoria Park has been the means of providing a great deal of pleasure to many local people in the town. Although its appearance and condition have varied between many successive bouts of renovation, it has always remained in regular service.

The bandstand was first designed and built by Hill & Smith in their Brierley Hill Foundry in the West Midlands. Their 1904 catalogue says it would have had an 'octagonal plinth, with wrought/cast-iron balustrades attached to cast-iron pillars supporting a domed roof with an ornamental weather vane and would be supplied and erected for the sum of £172 10s 0d'. Since, however, the very function of the bandstand is to create a venue for the bands, its history cannot be told without mention of the many bands which have played on it over the years. Although it was not built until the early 1900s, the need for a bandstand existed long before then.

Denton's very first band was formed in 1818 and began playing in public for various celebrations. The townspeople, and especially the hatter Joseph Howard, had subscribed generously to an appeal for funds. They were able to buy a set of instruments, music paper and instruction books for a grand total of £210. The big drum was duly painted with the title 'Haughton & Denton Band'. Haughton, however, was at that time a separate town and the Dentonians, who outnumbered the Haughtonians, objected to this and so the name was eventually changed to 'Denton & Haughton Band'. It was a very popular band and played for many years.

However, since 1859 it had a rival. This was the Baxendale's Band named after their small factory. As they went from strength to strength, they decided they needed a new name, and so they called themselves the 'Denton Original Band'. This distinguished it from the 'Denton & Haughton Band' and indicated that it was the original 'all Denton band'.

As its popularity grew, it eventually eclipsed its old rival. Its great achievement came in 1900 when it won £75 and the 'One Thousand Guinea Challenge Cup' at Crystal Palace, having competed against entrants from all over Great Britain and the colonies. There was much rejoicing in Denton at the time and this was the first band to play on the new bandstand in 1913.

The band had many assignments and a new custom had started in 1900. Whenever a member left the band to go and fight for his country, he was given a great send-off. He was marched from his home to Denton station by the entire band and a procession of well-wishers. The band played patriotic marches and hundreds of people turned out to watch.

By 1919, when they had celebrated their diamond jubilee, they were meeting in a dining room at the marketplace but moved later to the King's Head and then in 1973 to Denton Cricket Club on Egerton Street. In 1979, following a fire in their band room, the band folded, but from this came the 'Crown Point Band' and the 'Oldham Batteries Band'. The latter name was derived from their venue which was Oldham Batteries' Sports & Social Club but, as some members came from the former band, it soon regained its title of the Denton Original Band. In the 1990s it again reformed and adopted the title of 'Denton Brass'. They are still with us today.

In addition to the local bands, many others from all parts of the country have played on the bandstand over the years, and still do. They covered all types – such as military bands and especially colliery bands. Before the Second World War, brass band concerts had taken place there every Sunday afternoon and evening during the summer months. In 2007 it was restored to its former glory, after suffering from missing iron work, rotting wood and need of a re-roof, which will ensure this small but important heritage of Denton will be enjoyed for years to come.

Denton Original Band in the early 1900s.

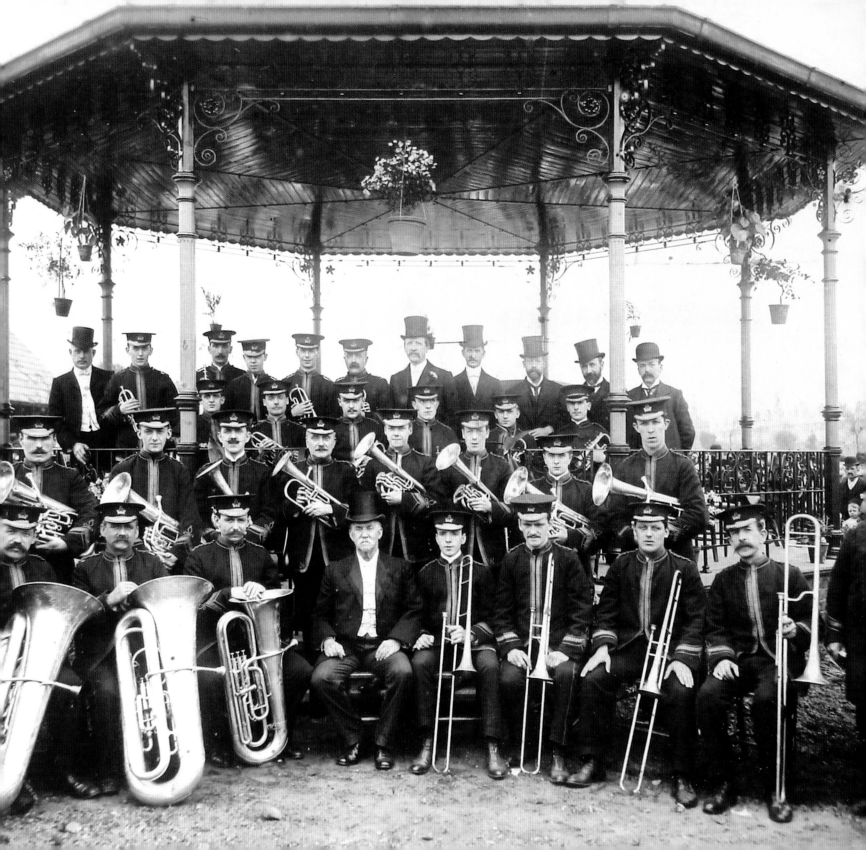

MONTPELLIER GARDENS, CHELTENHAM

Originally developed as pleasure gardens, Montpellier Gardens were designed to provide a suitable setting for the pump room and for the local Cheltenham society to meet and promenade. The gardens were mainly frequented by those taking the waters even though local people had to pay an admission fee. By the 1830s, the gardens consisted of a glasshouse which was filled with exotic plants, as well as a Chinese pagoda with an integral bandstand and an ornamental fountain. With the change more towards public ownership in the late nineteenth century, the pleasure gardens became more a place of 'public amusement, recreation and resort'. In 1864, the impressive and very ornate Coalbrookdale bandstand was constructed, and soon became a popular feature with regular concerts in the gardens. Built at the turn of the twentieth century, the proscenium building became the venue for theatrical and other popular cultural events. Other sports facilities were introduced and included lawn tennis, archery and croquet.

By 1893, Cheltenham Borough Council had bought Montpellier Spa and its gardens for £7,400. Like many public parks at the time, the history of the gardens during the early and mid-twentieth century was dominated by the dramatic impact of the First and Second World Wars, when they were appropriated for the war effort and used for the 'Dig for Victory' campaign as well as training and exercises, with the bandstand ultimately boarded up. However, by 1955, the gardens were eventually laid out in their current form and very few changes were made until the early twenty-first century. The rotunda was gradually restored by the local council with help from Lloyds Bank in the early 1960s and in 1994 the Civic Society initiated the eventual restoration of what is now the oldest remaining bandstand in the country, after misguided plans to convert it to a restaurant.

In Victorian and Edwardian times the Montpellier Gardens were a popular and fashionable venue, where elegant Cheltonians could stroll and listen to the band, and nannies would bring their charges, the babies in their beautifully built carriages. At that time the Gardens were surrounded by railings, and elderly residents who remember the twenties and thirties recall 'paying 2d (1d for children) to enter and listen to the band who played every day in the season'.

Extensive restoration and further development of the gardens was carried out in 2006 with the award of a major grant from the Heritage Lottery Fund. This latest restoration has meant that Montpellier Gardens will continue to play an important part in the lives of local people and the many visitors alike well into the twenty-first century.

The Coalbrookdale bandstand of Montpellier Gardens, Cheltenham.

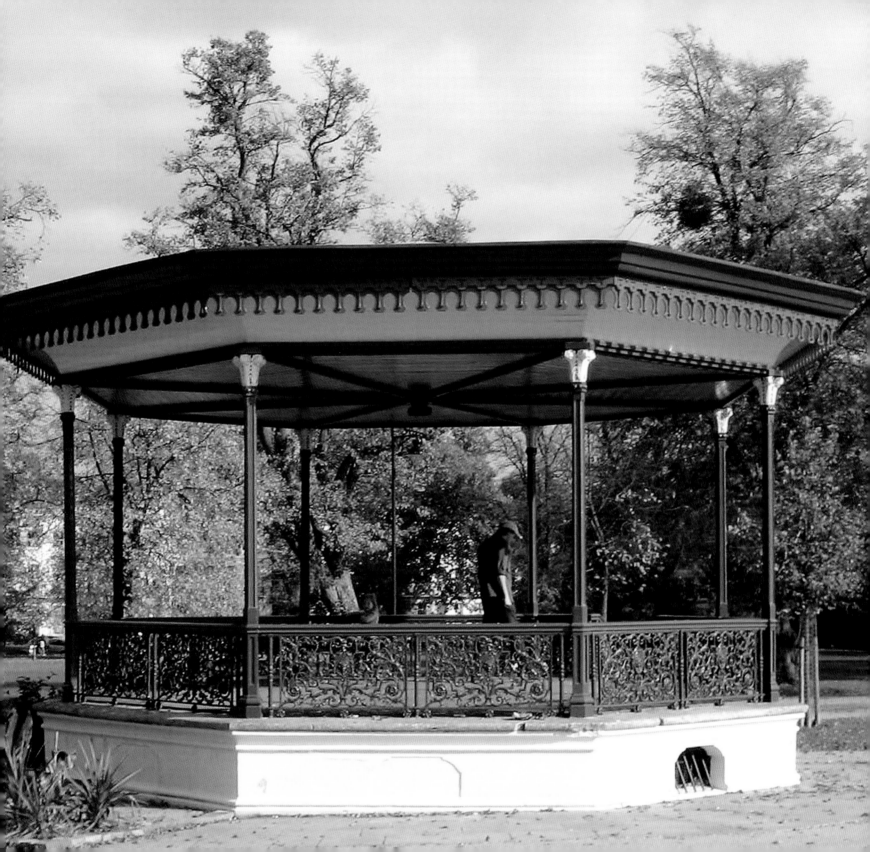

PUMP ROOM GARDENS, LEAMINGTON SPA

The Pump Room Gardens in Leamington Spa have been used for public events since they were first created in 1814. Initially the gardens were only open to patrons of the Royal Pump Rooms and bath for health-giving walks after taking the spa waters. The Pump Room Mall, which was set out at the side of the main building, was the resort of the fashionable of the place on Sunday evenings when a military band occupied the orchestra (bandstand) which was built of wood in the centre of the mall shortly after the main building had been completed. This is the first reference to a bandstand in the Pump Room Gardens, which is reputed to have lasted until 1868. In February 1876, the gardens were opened to the public without charge, due to the persuasion of the mayor, Samuel Thomas Wackrill. Since then they are viewed as a village green of the town with various events, annual or otherwise regular, and some 'one-off' occasions.

In 1871 Wackrill hired the gardens on sixteen Mondays to give a succession of fetes for the children of the poor and working classes who were day and Sunday school scholars. By 1889, tenders were being sought for the erection of a bandstand to accommodate twenty-four performers, in accordance with a plan proposed by Messrs Walter MacFarlane & Co., with the surveyor making additional entrances to the grounds with paths leading to the site of the permanent orchestra on drawings he had prepared. Opened by Whitsun in 1889, there were reports of concerts marred by 'unruly children'. The bandstand was erected by Walter MacFarlane and Co. and was one of the firm's standard bandstand designs (No. 224 as illustrated in their 6th edition catalogue of c.1882)

and was made from cast iron. In January 1898 the Pump Room Gardens head gardener was instructed to submit a plan showing how trees could be planted near the bandstand in order to afford shade in the summer.

In the first half of the twentieth century, bands played regularly in the summer months with spectators sitting in deck chairs to listen. When not in use the chairs were stored nearby in a wooden hut. The music committee asked the borough surveyor to obtain estimates for supplying curtains and

rollers and also revolving shutters in 1915. By 1924, revolving glass shutters were being considered 'to be put in hand for completion in time for the opening of the Summer Music Season'. This is the only remaining bandstand in Leamington Spa, with those in Jephson Gardens, Victoria Park and Eagle Recreation Ground long since removed. This delicate MacFarlane bandstand is well overdue significant restoration and the Friends of the Pump Room Gardens continue in their endeavours to see this fulfilled.

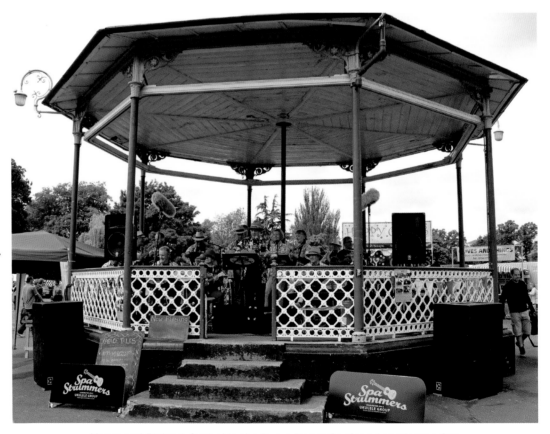

Above and Right: A festival in the Pump Room Gardens, Leamington Spa.

CASTLE FIELDS PARK, WELLINGBOROUGH

The Castle Fields bandstand in Wellingborough was built in 1913 for around £350. It hosted its first performance on Easter Sunday, and quickly became a key feature in the local community. In more recent years it has suffered from considerable vandalism and was closed and shuttered in 2008 and remained so until 2013. Much-needed work took place that year to restore this once elegant and grandiose structure, with the £75,000 specialist renovation project funded by money paid to the local borough council from developers that built flats and houses nearby. The bandstand was reopened in September 2013 with a more than impressive celebration of music in the park. Prior to the restoration, there hadn't been a performance at the bandstand for more than a decade as vandalism had forced it to close and effectively turned it into a derelict eyesore.

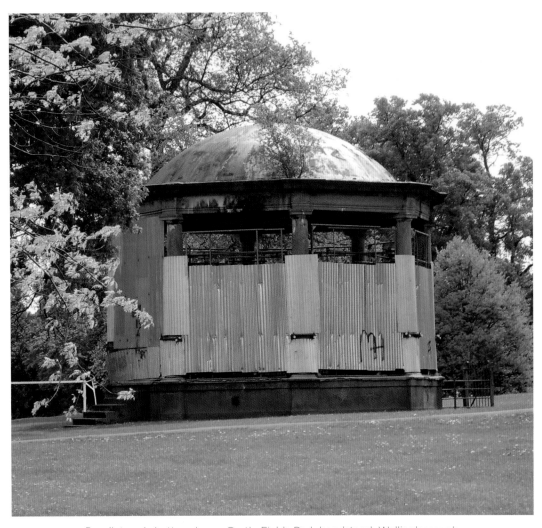

Derelict and shuttered up – Castle Fields Park bandstand, Wellingborough.

Restored and reopened in 2013.

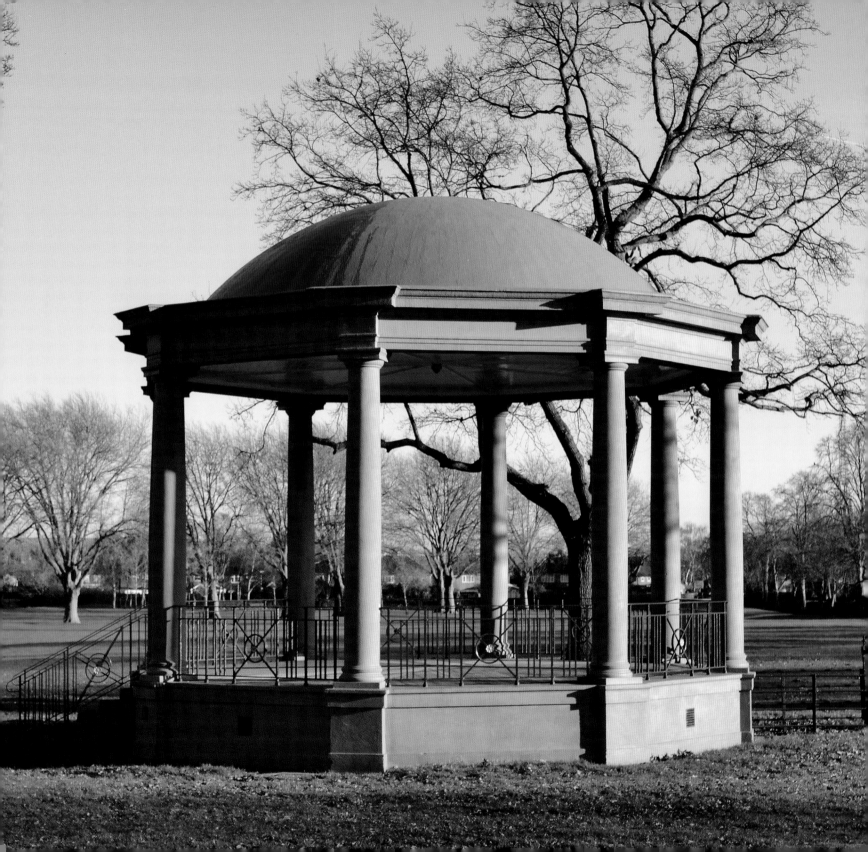

THE EMBANKMENT, BEDFORD

Bedford has a history of controversy when it comes to its stock of bandstands. Its timber twelve-sided bandstand erected in Bedford Park in 1888 is still in place. It is an impressive feature in this lovely park and is well looked after, but unfortunately little used as it is too small for the modern band.

It was, however, on the town's Mill Meadow where other bands played, having at the time, according to a newspaper in 1898, 'a useless plank platform' where it was 'so low that the children are all rolling and playing around the legs of the musicians'. The writer continued that 'any sixth rate continental town would have long ago run up a private subscription for a lightly ornamental, gaily painted, pagoda iron bandstand and would consider a plank platform a disgrace'. It was another thirty years before this appeared. In the meantime, a floating bandstand was erected in 1907 but did not last long, disappearing before the First World War. The Bedford town bandsmen decided to build their own out of three punts with a new floating platform just a foot above the water. The results were disastrous:

Thousands … gathered on the Embankment on Whit Monday, 1923 … while the silver instruments and the hopeful instrumentalists shipped aboard the floating bandstand from the Mill Meadows End. Eight or nine of the bandsmen congregated at the outward end of the bandstand, just as it pushed off from shore and were soon vastly perturbed to discover that their edge was sinking in the deep. Their hurried movements threw the band into confusion and the motion that ensued … did not improve the situation. The edge was soon awash and feet were getting wet. Three of them dived into the stream and swam ashore.

This was not the end of the Bedford bandstand problems. Rowell and Co. of London tendered to supply a cast-iron bandstand for £350 to which another £230 would have to be found for foundations and, for just under £150 more, windshields were added. The completed bandstand was officially opened on 10 April 1926 in the new St Mary's Gardens 'in the presence of several thousand people and in delightfully warm sunny weather'. But behind the celebrations was considerable local discord:

A cordial welcome was given to Luton Red Cross Band, whose very fine playing was greatly enjoyed. The effect, however, was seriously impaired by a most disconcerting echo, which certainly detracts from the musical value of the new stand. This, apparently, was foreseen by the members of the local bands and was partly the cause of their protest, although at the protest meeting on the Market Place last week, attended by four or five thousand people, it was made clear that the main grievance was that the Bedfordshire bands had been entirely ignored by the Corporation in connexion with the erection and opening of the bandstand.

The acoustics were a real problem where 'the tone hardened almost to harshness'. The protest meeting in the marketplace was attended by many of the local bands, and 'Mr J. Dunkley of the Trades Band said that all Bedford bandsmen had the greatest admiration for Luton Red Cross Band. They were proud of them as belonging to the same County, but if the Council liked to take £728 of the ratepayers' money and build a bandstand – in the wrong place to start with (laughter) – at the very least they might have consulted the local bands and invited one representative to be there.'

Eventually realising that the location was an unwise choice, the council made some money available during the Second World War to improve local recreational facilities, so the opportunity was taken to spend nearly £200 on moving the bandstand to its present site in Mill Meadows. However, there was yet another version of the floating bandstand that had been built and was used here until the iron bandstand was resited. Restored and relaunched in 2009, the first concert was this time performed by the Bedford Town Band.

Mill Meadows bandstand, Bedford.

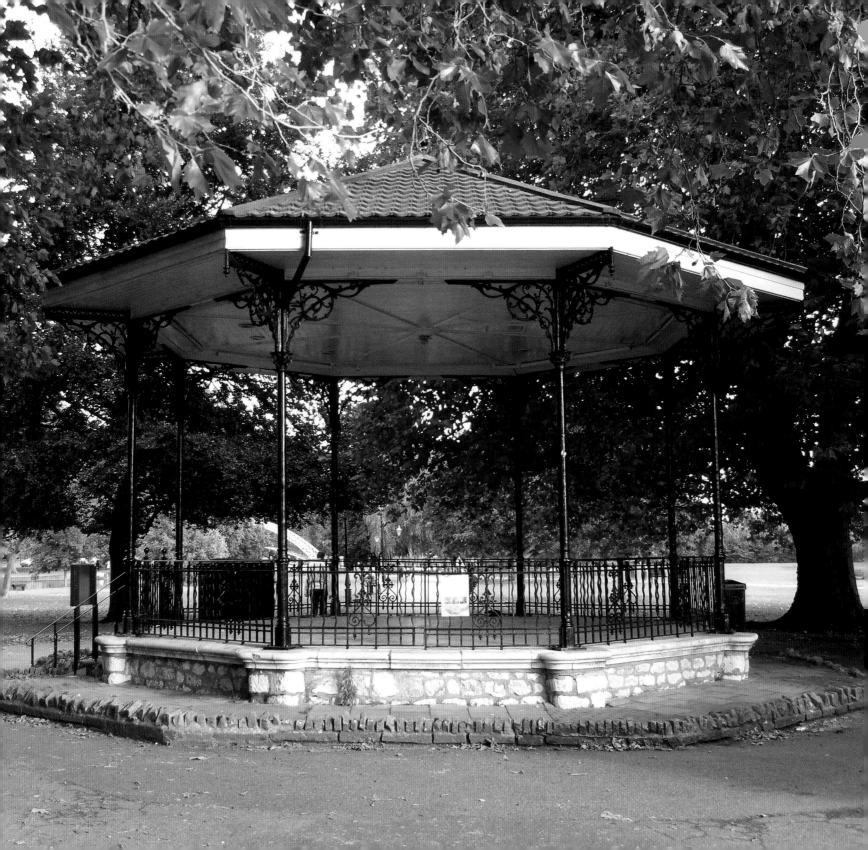

CASSIOBURY PARK, WATFORD

One of the remnants of the great lost estates of the United Kingdom – Cassiobury Park – is now the largest park in Hertfordshire, and the principal park of its primary town of Watford, covering an area twice the size of Hyde Park in London. But this is no ordinary town park nor is it a park that stems from the Victorian age. It is the remnant of the once great Cassiobury House and the estate of the Earls of Essex.

By the beginning of the twentieth century, the decline of the Cassiobury estate was obvious with large areas of the park sold off in 1909 and 1912 to Watford Borough Council for public parkland, despite the opposition of local people. By 1921 the lease on the house was surrendered and in 1927, the magnificent gothic mansion of Cassiobury House was demolished. Much of the remaining land was bought by the council and became further parkland. Despite the localised resistance to the acquisition of the new park, it soon became extremely popular with new facilities introduced.

Central to the new park was the introduction of a significant bandstand within an enclosure. Tenders were being invited in September 1911 'for a bandstand to be erected in Cassiobury Park'. A number of tenders were received including one from McDowall Steven & Co. for a No. 5 bandstand. However, it was a tender from Messrs Ensor and Ward that was accepted for the erection of a Hill & Smith bandstand in October 1911. *The West Herts Post* on 20 September 1912 reported:

Cassiobury Park Bandstand – this structure now appears to be shaping up under the supervision of Messrs. Ensor and Ward, builders and contractors, Watford who have got the work in hand [and] will shortly complete the whole structure. It is to be hoped the fine weather will prevail … The opening of the new addition to the Park takes place on Wednesday afternoon at 4.30 p.m. when the Artizan Staff Band will render a nice selection of music.

Cassiobury Park, Watford, bandstand arena.

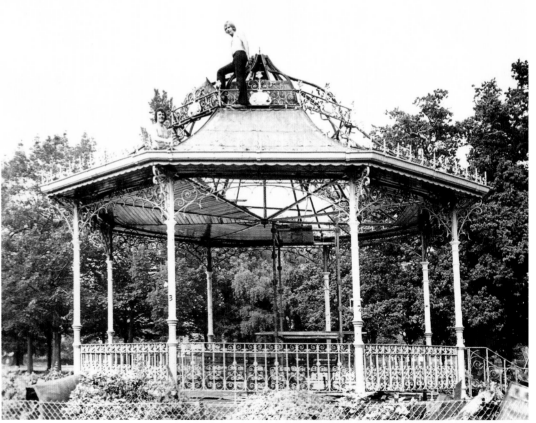

Removal of the Cassiobury Park bandstand in the 1970s.

Ready for restoration.

It was formally opened on the 27 September 1912. Screens were later added in 1914 and there were proposals to extend the bandstand area between 1920 and 1923. Immensely popular, *The West Herts and Watford Observer* reported on 15 September 1923, 'The season's band performances in Cassiobury Park concluded on Sunday with two programmes by the combined bands of the Coldstream Guards and the Welsh Guards. In the afternoon the enclosure was full, but at the evening performance the accommodation was taxed to overflowing, and thousands congregated around the bandstand.' In 1930, sales brochures for local estate developments describe Cassiobury Park's natural amenities 'with a band enclosure with seating for 1,500 people. First class military bands give performances every Sunday.'

By the 1970s the bandstand was a shadow of its former self and in 1975 it was in pieces in the council depot. A decision was made to re-erect it, but even this caused consternation locally with one councillor complaining about its proposed new position next to the library, 'I never thought this was a suitable place for a bandstand but having got a stupid concrete base we have got to do something with it'. It was subsequently reassembled but was never intended 'to be used by a band or for musical entertainment' but as 'an architectural feature'. Its condition is poor, missing its soundboard, and it has an appalling felt roof. Thankfully it is to be fully restored and returned to Cassiobury Park in 2015 as part of a major Heritage Lottery Fund restoration of the park.

LONDON

London has been witness to many concerts over the last 150 years, with nearly 100 bandstands in its many parks – from most of the Royal Parks, to the great parks of Battersea Park, Victoria Park, West Ham Park, Clapham Common, Southwark Park – as well as some of the quieter and more sedate City Squares such as Northampton Square and Arnold Circus. Jack Donaldson wrote in the *Daily Express* in 1937:

Sixty bands are engaged and play in different parks throughout the summer. Nearly every park has a band on Sunday evenings, from 7 to 9. On Mondays, Tuesdays and Fridays Victoria Embankment Gardens revels alone, but on Wednesdays Bethnal Green Gardens and Deptford Park join in, and on Saturdays, Highbury Fields, Islington, and Clissold Park.

But on Thursday there is music from Kilburn Grange in the north to Mountsfield Park, Lewisham, in the south, and from Horniman Pleasance, Kensal Road, in the west to the Recreation Ground, Wapping, in the east. Then Hyde Park daily and Green Park, Regent's Park and Kensington Gardens on Sundays …

CLAPHAM COMMON

The Clapham Common bandstand is the oldest and largest surviving in London and one of the largest ever built in England. In short, along with the Brighton bandstand, it is the most magnificent of them all.

In 1889 local residents petitioned the London County Council for 'the great need our beautiful Common has for the erection of a Band Stand'. The London County Council (LCC) was at the time encouraging the playing of music in parks and, without hesitation, agreed to the Clapham petition, allowing a budget of £600. It took nearly a year for the common to eventually get its bandstand and its story is an unusual one.

In 1861, the Royal Horticultural Society had opened new gardens in South Kensington, on the site which now lies between the Natural History Museum and the Albert Hall. These gardens had two large bandstands, designed by Francis Fowke, the engineer who later designed the Albert Hall in the 1880s. When the gardens closed the bandstands were bought by the LCC, which re-erected them in Southwark Park and Peckham Rye (both destroyed in the Second World War – Southwark Park has

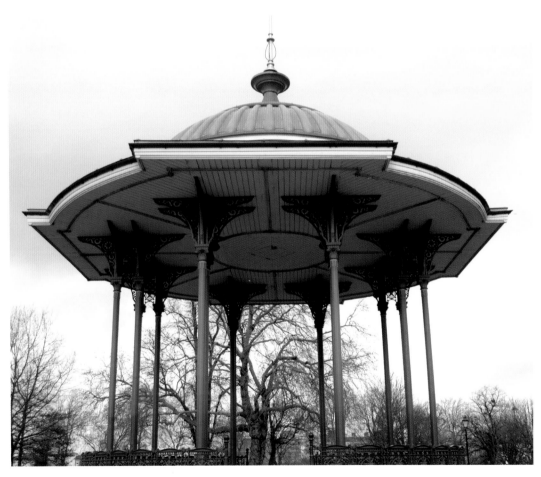

Restored and sitting majestically on Clapham Common once again.

since been replaced). It was the contractor who was relocating the South Kensington bandstands who suggested to the LCC that a duplicate might be made for Clapham Common. The LCC architect Thomas Blashill took up the idea and drew up plans for a replica, slightly modified for reasons of cost. The ironwork came from George Smith's Sun Foundry in Glasgow and in 1890 the Clapham Common bandstand was eventually delivered for the sum of £598. Concerts at first were held only on Wednesday afternoons, but by 1891, Sunday concerts had begun, on condition there was to be no dance music. The following twenty years saw regular concerts with professional as well as traditional police and military bands. At first some of the seating was free but from 1895 all was charged for. Regular use of the bandstand continued till well after the Second World War, but by the 1960s, it was deemed old fashioned, despite bands like Dire Straits and the Darts playing there in 1977.

Dire Straits playing in 1977 on the common.

The rot had firmly set in and the pigeon-infested bandstand was now 'at risk' according to English Heritage. Faced with its likely collapse, in the summer of 2003 the Friends of Clapham Common and the Clapham Society persuaded the owners, Lambeth Council, to participate in a major fundraising and restoration project. With a successful Lottery Grant of £900,000, one of the challenges facing the restorers included replacing the wooden frame for the giant cupola. The zinc of the cupola came from France and an Indian factory supplied the cast-iron balustrade. The work started in September 2005 and continued through the winter and early spring. On 15 June 2006 the bandstand was reopened by the Mayor of Lambeth with music by the Merton Concert Band.

NORTHAMPTON SQUARE, LONDON

Until the mid-seventeenth century, much of the area known today as Northampton Square was un-worked grassland forming part of the Compton family's estate. When the family's head, the Marquess of Northampton, moved the family home to the newly built Castle Ashby in Northamptonshire at the turn of the sixteenth century, the wider Clerkenwell area was still largely rural. The area where the square would later be established was flanked by St John Street and Goswell Road, major routes from the north to London's historic centre and the Thames.

Acoustic gigs are a common occurrence in Northampton Square bandstand.

In the sixteenth and early seventeenth centuries, the most prominent building in the area was the Compton's family home on St John Street.

By the beginning of the eighteenth century, the area had become a local centre of the meat trade, benefiting both from its strategic location near the Thames and its position downwind of Westminster. Butchers would carry out their work in Clerkenwell before disposing of waste material in the nearby New River, which was still at surface level. Meat and offal were sold in nearby markets and skins were tanned and sold as leathers locally.

The years of the Industrial Revolution witnessed rapid expansion in Clerkenwell. New streets were laid out in the late eighteenth and early nineteenth centuries, crossing the previously untouched grassland that would later become Northampton Square. In the early nineteenth century, Spencer Street was also introduced with a substantial Quaker workhouse and orphan asylum built along the north-east corner of what was soon to become the new square. In 1827, the remains of dozens of plague victims were unearthed during the urban expansion in the area, having been buried along the line of St John Street. The Compton family, which had not occupied the area for some time, turned their former residence on St John Street into a school for girls, the Ladies' Manor School, which remained until the mid-nineteenth century and served later as a lunatic asylum. As the area developed residentially in the early nineteenth century, townhouses were erected in a circular formation around an area of open ground. It was at this point that the urban topography of the area began to take on a form familiar to us today and for the first time 'Northampton Square' is found on contemporary maps.

In 1832 the square's gardens were laid out by the Marquess of Northampton of the time. In 1885, William Compton, the fourth Marquess, in honour of his daughter, Lady Margaret, opened a public garden, and donated the land to the Clerkenwell Vestry. Throughout this period, the gardens appear to have been well used by the local community. Well before any sort of bandstand was erected, musical performances were a regular feature in the square. By 1900 the area had changed and was now mainly occupied by jewellers and horologists.

Between the First and Second World Wars, intense urbanisation led to the loss of many green spaces in the Clerkenwell area with issues around public health and recreation becoming a significant political issue. In 1930, Finsbury Borough Council started a campaign to improve local open public space. Northampton Square was already very highly valued by the local community, so was an obvious choice for enhancement. With the principal aims of creating a public shelter for, 'those people who mainly for health reasons must have fresh air all year round', as well as to allow band performances, the bandstand was erected in the centre of this much-improved square. It was officially opened by the Mayor of Finsbury, Alderman W.H. Martin on the evening of 17 September 1930, in a ceremony which consisted of speeches, hymns as well as a performance by the Band of the Finsbury Rifles.

Today, the basic structure of the bandstand remains sound and has undergone a major refurbishment programme. It is London's last remaining historic bandstand in a residential square, as the majority of London bandstands are found in large parks and commercial areas. It has also experienced a recent resurgence of use for popular entertainment, having become an unofficial venue for regular acoustic performances.

BECKENHAM RECREATION GROUND, CROYDON

Croydon Road Recreation Ground was purchased by the Beckenham Local Board to provide public open spaces which had been lacking since the 1870s. The park first came into use in the autumn of 1890 but its formal opening was on 23 September 1891. On that date 'the village was ablaze with flags and bunting as the gentry, clergy, tradesmen, representatives of every organisation, and all the schoolchildren – each wearing a medal specially minted for the occasion – made their way to the new park with bands playing and church bells pealing'. Since it was opened in 1891 by Tom Thornton, owner and editor of the *Beckenham Journal*, this bandstand has been a major part of the wide and wonderful history of this popular local park: for instance, it was used by Beckenham's Harold Bride, the junior wireless officer on the ocean liner RMS *Titanic*, to make a speech to cheering crowds in the park as well as witnessing civic and royal ceremonies, balloon flights and flower shows which used to rival Chelsea in their popularity. But this park was to witness a unique and memorable music event many years later. In mid-1969, David Bowie was still a long way from superstar status, despite having been in the music business for several years. He was living in Beckenham with friend Mary Finnigan, and appeared most Sundays at The Three Tuns public house in Beckenham High Street.

These shows began as a way for him and Mary to make a little money and to showcase his talents, but developed into what was christened the Beckenham Arts Lab 'Growth'. As a further development of the Arts Lab idea, and in the hope of raising money

The 1969 Free Festival with David Bowie in Beckenham Rec.

to fund permanent premises, it was decided to organise a free festival at Beckenham Recreation Ground on 16 August 1969. Bowie rang his friends in the music business but didn't get many positive replies from named artists. For example, the manager of Noel Redding (who had just left the Jimi Hendrix Experience and was now leading a group called Fat Mattress) said, 'Noel Redding is a superstar and doesn't play free festivals'. In the end Bowie played solo, and the bill also included singer-songwriters Bridget St John, Keith Christmas and Toni Visconti. There were numerous stalls at the festival selling jewellery, ceramics, herbs and food (including hamburgers cooked in a wheelbarrow by Angela Bowie-to-be). On the day the weather was exceptionally good and Bowie played many of the tunes which would eventually appear on his *Space Oddity* album, such as the title track, 'Janine', 'Wide-Eyed Boy From Free Cloud' and 'An Occasional Dream'.

This unusual bandstand was supplied by McCallum & Hope Ltd of Glasgow who were in business from 1880 until 1921, and were an astounding enterprise supplying all aspects of architectural ironwork. However, in 2013, a condition survey revealed that the bandstand was in reasonable condition but in need of repair and required replacement of certain of its elements. A campaign was started in late 2013 with memorabilia donated by Bowie himself.

Myatt's Fields Park has a rich and interesting history and was first opened to the public in May 1889. Named after Joseph Myatt, a tenant market gardener, who grew strawberries and rhubarb here in the nineteenth century, it was Fanny Wilkinson, one of the first professional women landscape gardeners and an active campaigner for women's suffrage, who designed the park. It was ultimately laid out by the Metropolitan Public Gardens Association at a cost of £10,000. This was significantly also made possible by a grant from the Lord Mayor's Fund for the unemployed. Jack Donaldson writes of Myatt's Fields:

To see the poorer, and to me, more attractive audience, you must go to Myatt's Fields, Camberwell, also on a Thursday. This is a pretty little park which not long ago was a market garden, 'with cabbages growing instead of flowers', as I was informed. The band plays in a circular railed bandstand, with a wider circle of railings shuttered off a space from the tennis and cricket. I arrived punctually at 7.30, but there was no sign of room on the seats and I couldn't squeeze onto the railings. So I selected a tree to lean against, which I shared with a thin elderly workman.

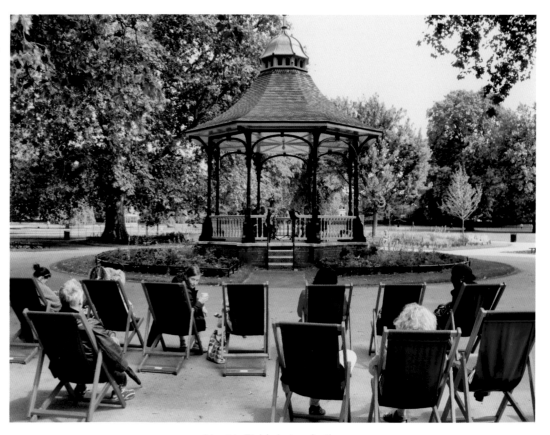

Myatt's Fields in Lambeth.

His tour of London's bandstands summarised Myatt's Fields as being the best evening of all: 'Tchaikowsky was the only classic, but there was an Overture by Bilton, which, with the noise of the crowd, and one's eyes shut, sounded like a scene from a Rossini opera.'

EATON PARK, NORWICH

For obvious reasons, the years following the First World War were a time of severe unemployment and hardship for many. In 1920 the minutes of the Norwich Corporation recognised the impact that high unemployment was having locally and as a result it sent a resolution to central government to the effect that all 'unemployed persons should be paid at a rate that would sustain them in health and efficiency until they found work'. The corporation took advantage of government grants, with a bold decision to design and construct several formal parks in Norwich as a means of unemployment relief. The major figure in the construction of many of Norwich's parks was Captain Arnold Sandys-Winsch who was appointed as parks superintendent and his impact was incredible.

Although there was plenty of land available at that time (the area of Eaton Park was then among fields and market gardens) it was certainly well recognised that a place for recreational purposes was needed for local people to use. Funding was required and with this in mind, £900 was raised for the piece of land which was enclosed and which we now know as Eaton Park. For over three years more than 100 men were employed to build the majestic bandstand, impressive pavilions, and quite magnificent model boating and lily ponds. In the middle of the park a domed bandstand, surrounded by quadrant pavilions, was erected. These structures were all designed by Sandys-Winsch. Also to the captain's designs, A.E. Collins, the then city engineer, was responsible for the building of the model yacht and lily ponds on a radial from the bandstand, terminating with a water pavilion, serving as

Dramatic skies over Eaton Park's bandstand.

a club house for those using the yacht pond. Tennis courts (there were over forty), cricket squares, bowling greens, other sports and leisure areas and gardens were created. In 1928 the park was officially opened by the then Prince of Wales who proclaimed 'it is a scheme that has provided a great slice of the country almost in the middle of a great City'.

The opening of Eaton Park by the Prince of Wales in 1928.

BRIGHTON

The Brighton bandstand, also known as the Birdcage and the Bedford Square Bandstand, was designed by Phillip Causton Lockwood in 1883, manufactured by Walter MacFarlane & Co. and constructed in 1884. It was designed as part of a project that included landscaped enclosures and covered shelters to improve facilities on the seafront in Brighton and Hove. It was originally intended as a sheltered area for ladies to rest in and admire the sea views, but soon became host to bands and gentlemen. The designer, Philip Lockwood, studied architecture in London before marrying a local Brighton and Hove girl and settling in Kemp Town. He was Brighton's borough surveyor for over twenty-five years and designed several local structures, many depicting the delicate latticed arches that are such a significant emblem of this exquisite bandstand. His seafront

Hove bandstand on the seafront at the Western Lawns, removed in 1965.

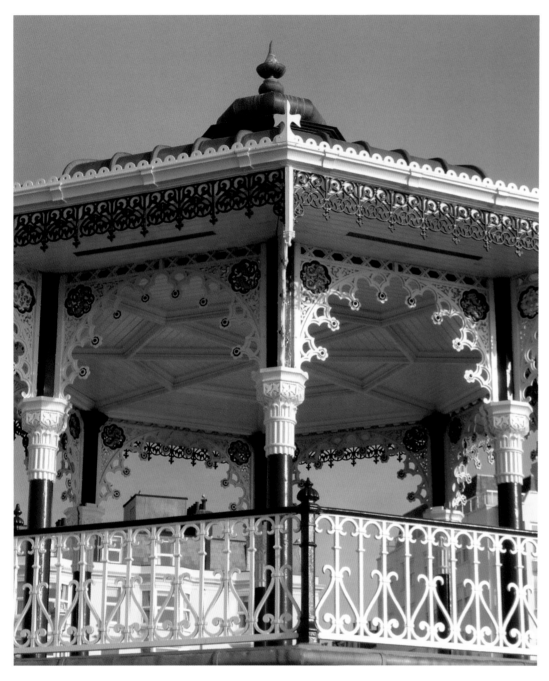

Restored to its beautiful best.

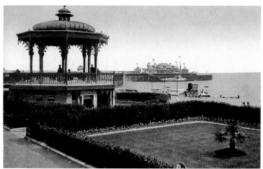

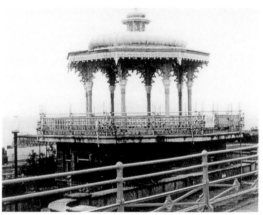

Derelict and forlorn.

designs were expensive and controversial at the time, but are now highly regarded. The Brighton bandstand is considered one of the finest examples of a Victorian bandstand anywhere and is the only one remaining in Brighton. In 1910 there were eight bandstands including one further along the seafront in Hove where the Babylon Lounge now stands. That bandstand was torn down in 1965.

The Brighton bandstand was a popular venue for bands through the early 1960s until a change in appreciation for historic preservation took hold of Brighton in the mid-1960s. The bandstand began to decay from neglect, and the bridge connecting the bandstand to Kings Road was

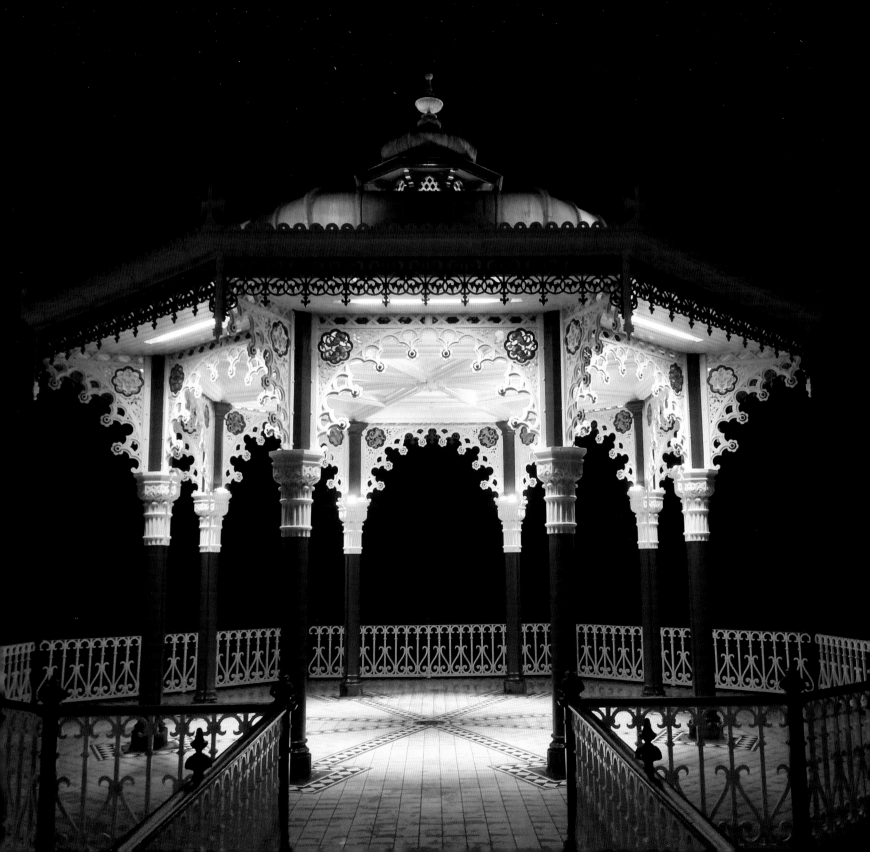

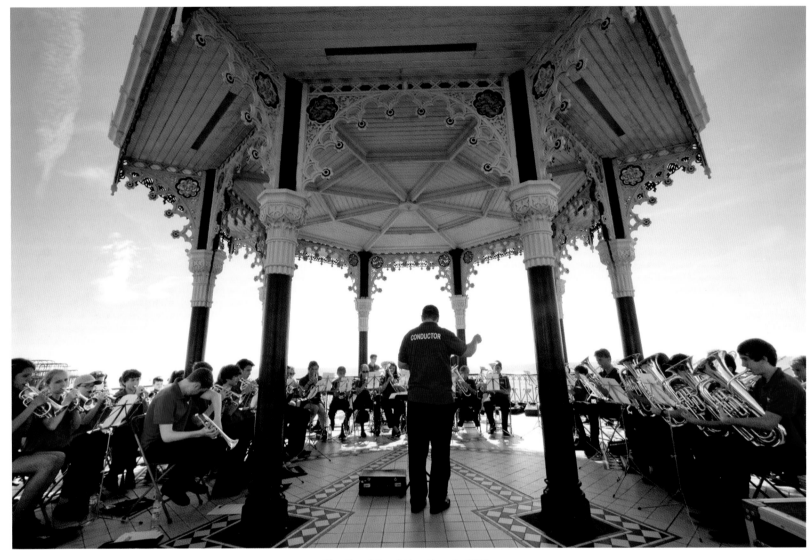

The Bandstand Marathon in 2012.

removed in the 1970s for reasons of safety. The bandstand had been left unused ever since then and it was likely that forty years of neglect would have seen the demise of this jewel in the prom's crown, if the Brighton Bandstand Campaign had not been set up in 2007.

In May 2007 the newly elected Councillors of Brighton and Hove City Council, with the backing of all political parties, agreed to fully fund its renovation. The restoration work started in September 2008, and the roof and cast-iron metal super-structure was restored in two different Sussex specialist workshops. The 2,500 people who signed the petition to see it restored eventually were lucky enough to see it fully reopened and in use as both as a musical venue and cafe by the summer of 2009. It remains the most impressive of any bandstand in Britain.

BOROUGH GARDENS, DORCHESTER

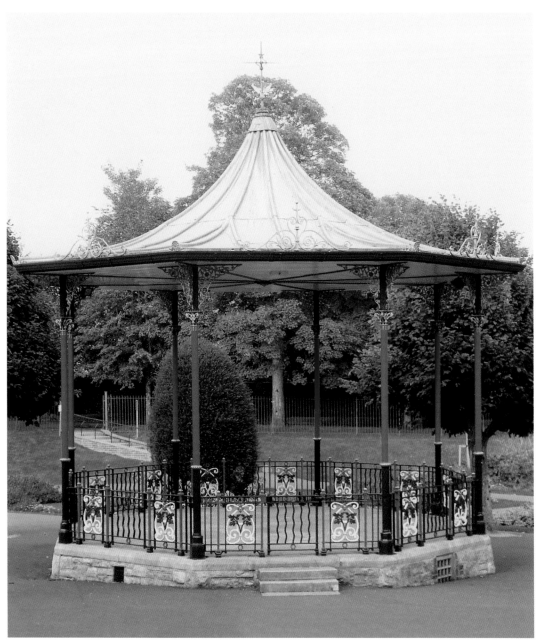

Dorchester Borough Gardens bandstand.

The beautiful Borough Gardens in Dorchester were laid out to an agreed plan by William Goldring of Kew, and were eventually opened to the public on 30 July 1896. They were intended as a gift to the people of Dorchester 'for the health and recreation of the inhabitants'. The gardens were established as a result of the philanthropy of Mayor Alderman G.J.G. Gregory and his achievement was celebrated with the commissioning in 1898 of the fountain in the dell by Charles Hansford in memory of 'Alderman Gregory'. Further philanthropy was witnessed by the donation of the ornate and highly decorated clock tower in 1905 by Charles Hansford. But this is wonderfully complemented by the beautiful, yet simple bandstand, designed by G.J. Hunt, the borough surveyor, for £200, again from the MacFarlane Foundry in Glasgow. It was erected in 1898 to celebrate Queen Victoria's diamond jubilee with the help of former MP Colonel W.E. Brymer. Additions over the years have included tennis courts, a bowling green, paddling pool and children's playgrounds. Memories of the bandstand are many and include Derek, who remembers Dorchester Town Band, which was made up of ex-army musicians, the brainchild of Mayor Freddie James, a well-known Dorchester character. Concerts on a Sunday would start at 8 p.m. – after the Boys Brigade and the congregation had come out of the chapel. 'Nights of Gladness' and 'In a Monastery Garden' were popular numbers in the bands repertoire. Other entertainments included an accordion band and a man playing a saw!

VENTNOR PARK,
ISLE OF WIGHT

Erected in 1887, this rather unusual MacFarlane bandstand now resides in sub-tropical Ventnor Park on the Isle of Wight having began its life on the now sadly lost Ventnor Pier. Described as looking like a UFO, this one really does look like a hovering flying saucer landing in verdant Ventnor Park. Sadly, it has lost many of its original features including its baluster panels and large parts of its lead roof to thieves. Restored in 2014, this beautiful old-fashioned Victorian park still hosts jazz and brass bands every summer.

VIVARY PARK, TAUNTON

Descriptions of the history of the park and bandstand are detailed in the early beginnings of Vivary Park:

The Park layout was then pegged out on the ground in February 1895, 'in accordance with the general idea shown on Mr Poynter's Plan' and the Committee held its next meeting in the Park itself, during which they seem to have altered various aspects of the design. They moved the path along the eastern side of the Park further away from the boundary with the gardens of the properties on Mount Street, and they increased the width of the paths from 10 to 15ft. At the same meeting the location of the bandstand was fixed and it was resolved that the approach to the southern entrance should be widened, and the entrance itself be enlarged so that vans could turn and enter the Park more easily. The borough surveyor was then instructed to commence work on the Park on 22nd February. The Council invited tenders for the design and construction of the main entrance gates, and for a Bandstand. Messrs Walter MacFarlane & Co. of Glasgow's Saracen Foundry won the contract for supply of the gates, which were completed by May. The Bandstand was supplied by Messrs H. Phillips & Son at a cost of £444/00/- and was completed by 18th June in time for the first concert in the new Park given by the Taunton Town Band.

This popular design, listed as No. 249 in the catalogue, has stood the test of time particularly well, with some other excellent examples in Malvern, Chesterfield, Colchester, Rochdale, Long Eaton and Hexham. Many have disappeared although two fine examples still remain overseas including Pretoria Park and Pietermaritzburg Cricket Ground in South Africa and are a wonderful legacy for the MacFarlane Saracen Foundry.

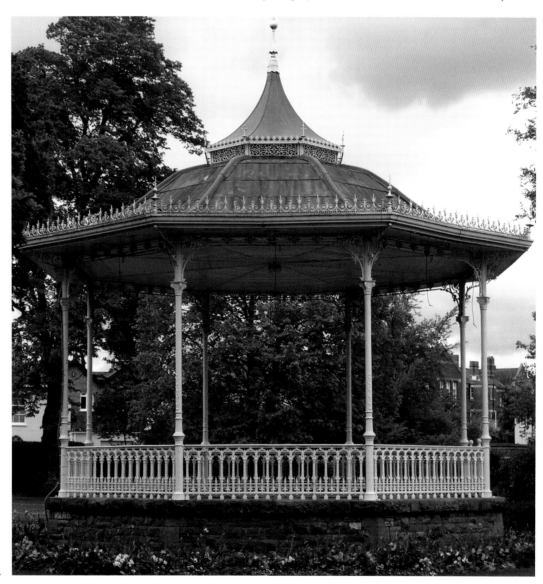

A Walter MacFarlane No. 249 bandstand in the immaculate Vivary Park, Taunton.

BEDWELLTY PARK, TREDEGAR

The evolution of Tredegar Park in South Wales is very closely linked to the coal and iron industry in this area as well as the history of Tredegar House itself. In 1895, the Tredegar Ironworks was closed down after a period of inactivity with the loss of 1,500 jobs. From around this time the local economy became more reliant on coal production from the nearby collieries. There was a brief respite as the works opened briefly once again the following year, but were once again closed by the time the original lease had expired in 1899 with Lord Tredegar refusing to allow it to be renewed unless the Tredegar Ironworks started production again. However, even with this fresh start the works had closed once again by 1901.

On hearing that the Tredegar Iron and Coal Company intended to surrender their tenancy of the Bedwellty House and Park in 1899, the Urban District Council contacted Lord Tredegar and made enquiries about the possibility of acquiring and converting the grounds into a 'Public Park and Pleasure Grounds'. As a result of this approach, Lord Tredegar donated at no cost the park and house to the council with an agreement signed on 23 October 1900. It was only a month later, on 24 November, that the Revd Alfred Barrett, JP, the chairman of the Urban District Council, informally opened the park to the public. Unusually, it was not officially opened until 18 April in the following year.

By the middle of 1901 the council were discussing whether Bedwellty House could be 'utilised for offices' and as a result, in late October that year, the first meeting of the council was held in 'the Council Room, Bedwellty House'. Community benevolence was strong within the area, as both individuals and organisations, donated park seats, and the Bedwellty Park Athletic Club was also formed, providing the necessary equipment to utilize the new bowls and tennis facilities. The council soon after erected the Long Shelter in 1910 and a Ladies Shelter in 1911, sadly now demolished. It was in 1912 that the Athletic Club raised the funds for the building of the park's bandstand, supplied by the West Midlands foundry of Hill & Smith. By 1920 there was a large network of paths that had been laid and meandered throughout the park with two new entrances added to the west and north-west. During the economic depression in the 1930s, local unemployed men excavated an open-air swimming pool which eventually opened in 1932. Without doubt, it was one of the most popular features of the park for many years, until numbers began to diminish, leading to the pool's eventual closure in 1987.

The bandstand was, however, extremely popular. Opening on 3 June 1912, it recently celebrated its centenary. At its opening, William North Esq. JP had presented it to the Urban District Council on behalf of the Bedwellty Park Athletic Club. The band of the HM Royal Marine Artillery played in the bandstand, to commemorate that wonderful occasion, and was led by bandmaster Lieutenant B.F. Green. Now recently restored with significant alterations to its roof, it continues to host band concerts on a regular basis and is an excellent companion to its 'sister' bandstand in Watford, Hertfordshire.

VICTORIA GARDENS, NEATH

The bandstand in Victoria Gardens, Neath, was erected in 1898. This was yet another Scottish bandstand but from the James Allan Snr & Son Elmbank Foundry (similar bandstands still exist in Swindon, Sherborne and South Shields). Established by James Allan at No. 138 Argyle Street, he originally worked as a tinsmith and furnishing ironmonger, and later advertised himself as a furnishing ironmonger, tinsmith, blacksmith, gasfitter and brass and iron founder. Taking his son into the business, the foundry was also known as James Allan Snr & Son. Like its competitors, such as the Saracen, Sun and Lion foundries, they produced prodigious amounts of decorative architectural ironwork, bandstands and drinking fountains. By 1920, the firm had expanded with a new foundry, the Lambhill Works, had opened an office in London, and received orders for an astonishing number of products

which sustained it through two world wars and into the late twentieth century as one of the last of the great Glasgow foundries.

As well as their fountains, bandstands and architectural castings, their main output consisted of entrance gates, airship sheds, seaplane sheds, altars and grave railings, railway stations and bridges, engineering workshops, fire escapes and sanitary items in iron to name but a few of their many products.

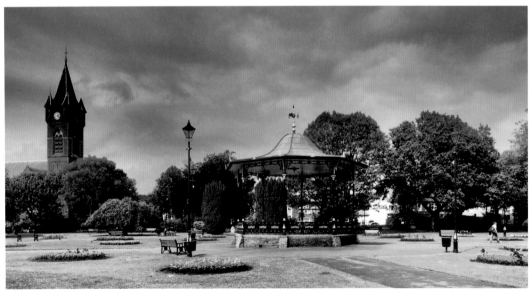

REVIVAL

The revival continues, with many bandstands restored and in some cases new ones introduced and lost ones replaced. The days reported by Jack Donaldson will never be repeated but bandstands are once again central to many of our public parks. The importance of Walter MacFarlane, George Smith and McDowall Steven are recognised and their designs at the time were bold and imaginative and are still very much so today. The revival continues.

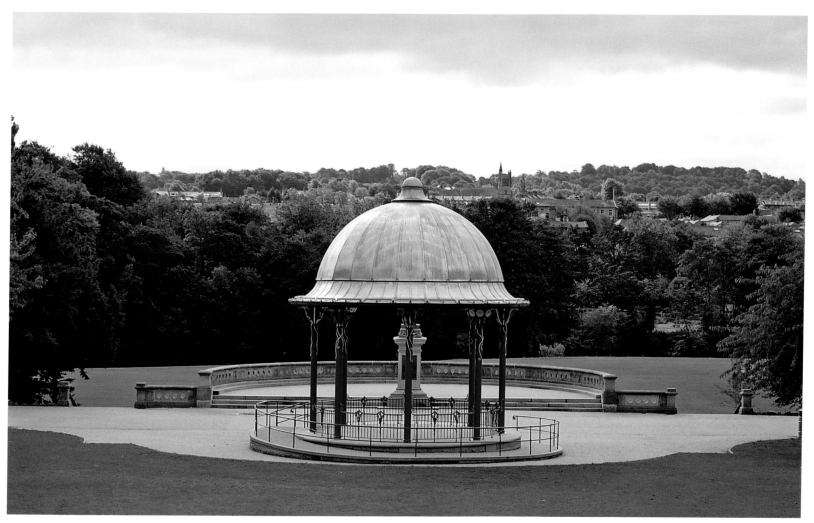

Roberts Park, Saltaire, a stunning replacement bandstand, both contemporary and complementary in the Saltaire World Heritage Site.

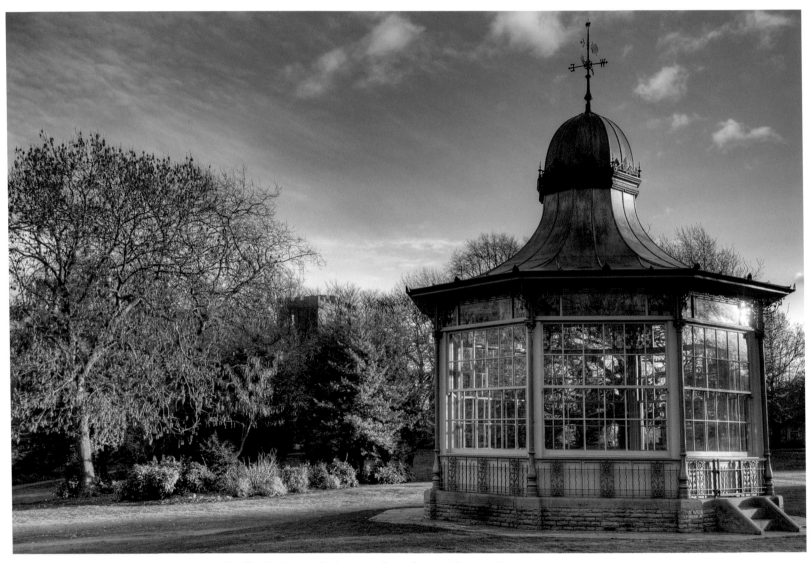

Sheffield's Weston Park, now a focus for weddings and summer concerts.

Lister Park, Bradford.

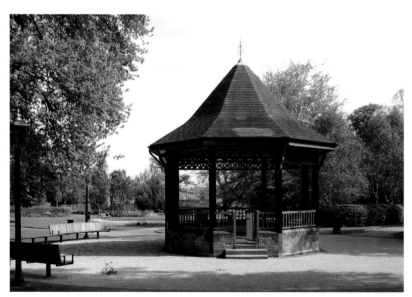

Caldicott Park, Rugby.

Palfrey Park, Walsall.

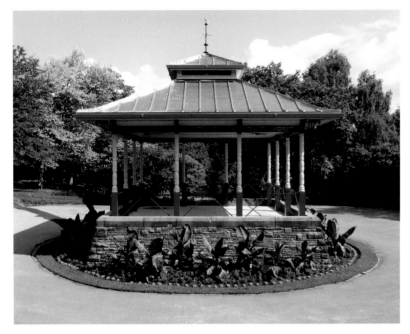

Beaumont Park, Huddersfield.

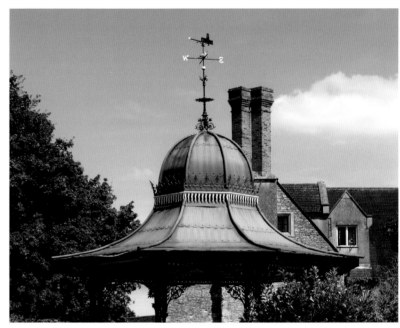

Thame bandstand, Oxfordshire.

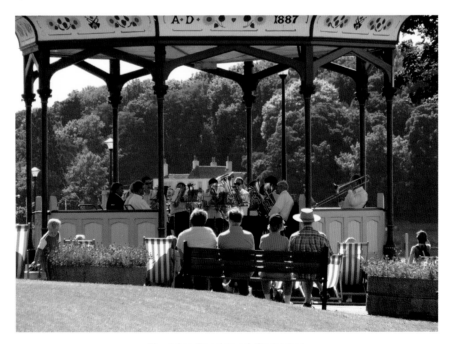

Clevedon Bandstand, Somerset.

GAZETTEER

Town	Location	Status	Date	Foundry	Model
Aberdare	Aberdare Park	Existing	1910	Hill & Smith Ltd, Brierley Hill, W. Midlands	
Aberdeen	Duthie Park	Existing	1893	McDowall, Steven & Co, Milton Ironworks, Glasgow	
Aberdeen	St. Nicholas Centre	Existing	1985		
Aberdeen	Union Terrace Gardens	Lost	1879	George Smith & Co, Sun Foundry, Glasgow	
Abergavenny	Bailey Park	Existing	c.1909		
Abertillery	Abertillery Park, Monmouthshire	Lost			
Aberystwth	Marine Terrace	Existing	1935		
Accrington	Oak Hill Park	Existing	1929		
Accrington	Oak Hill Park	Lost	1893	Walter MacFarlane & Co, Saracen Foundry, Glasgow	
Acton	Recreation Ground	Lost	1889		
Airdrie	Public Park	Lost	1897	Walter MacFarlane & Co, Saracen Foundry, Glasgow	
Alloa	West Park	Lost		Walter MacFarlane & Co, Saracen Foundry, Glasgow	
Alton Towers	Alton Towers	Existing	1928	Hill & Smith Ltd, Brierley Hill, W. Midlands	
Alton, Hampshire	Town Park / Public Gardens	Existing	1935		
Altrincham	John Leigh Park	Lost			
Ammanford, Wales	The Park	Existing	1936		
Andover	Recreation Ground, Vigo Rd	Lost	1930		
Annfield Plain	The Park	Lost			
Ascot	Race Course	Existing			
Ashbourne	Memorial Park	Existing	1950		
Ashford	Victoria Park	Lost	1901	Lion Foundry Co Ltd, Kirkintilloch	
Aylesbury	Vale Park	Existing	c.1980		
Ayr	Esplanade	Existing	c.1950		
Ayr	Low Green	Lost			
Balsham	Princes Memorial	Existing			
Bangor, Co Down	Marine Gardens	Lost		Walter MacFarlane & Co, Saracen Foundry, Glasgow	225
Barking	East Street	Existing			
Barking	Barking Park, Dagenham	Lost			
Barnard Castle	Bowes Museum	Lost	1912	Lion Foundry Co Ltd, Kirkintilloch	
Barnoldswick	Letcliffe Park	Existing			
Barnsley	Locke Park	Existing	1908	Lion Foundry Co Ltd, Kirkintilloch	23
Barnstaple	Rock Park	Lost			
Barrhead	The Cowan Park	Existing	1911		
Barrow in Furness		Lost		James Dunn Park (Vickerstown Park)	
Barrow in Furness	Barrow Public Park	Existing			
Barry	Victoria Park aka Romilly Park	Existing	1910	Hill & Smith Ltd, Brierley Hill, W. Midlands	
Barry Island		Existing			
Basingstoke	War Memorial Park	Existing	1902		
Basingstoke	Pleasure Grounds	Lost			
Bath	Royal Victoria Park	Existing	1903	Walter MacFarlane & Co, Saracen Foundry, Glasgow	
Bath	Hedgemead Park	Existing	1889	George Smith & Co. Sun Foundry, Glasgow	
Bath	Parade / Institution Gardens	Existing	c.1920		
Bath	Sydney Gardens	Lost	1920s		
Batley	Wilton Park	Lost			
Beamish Museum	Beamish Museum	Existing	1907	Walter MacFarlane & Co, Saracen Foundry, Glasgow	279
Bedford	Mill Meadow, St Mary's Embankment	Existing	1926	David Rowell, London	
Bedford	Mill Meadow, St Mary's Embankment	Lost	1907		
Bedford	Bedford Park	Existing	1888		
Beer	Melody Close	Existing	1986		
Beeston	Recreation Ground	Lost			
Beeston	Dovecote Lane Recreation Ground	Existing	1909		
Belper	River Gardens	Existing	1903		
Belvedere	Recreation Grounds	Lost			
Berwick on Tweed	The Park, Spitall	Existing	2006		
Beverley	Market Place / Cross	Existing			
Bewdley	QEII Jubilee Gardens	Existing	2005		
Bexhill on Sea	West Parade	Lost			
Bexhill on Sea	De La Warr Pavilion	Existing	2001		
Bexhill on Sea	Sea front pavilion	Lost			
Bicester	Garth Park	Existing	1997		
Bideford	Victoria Park	Existing	1912		
Bilston	Hickman Park, Wolverhampton	Existing	1938		

Town	Park	Status	Date	Manufacturer	Ref
Bingley	Myrtle Park	Existing	1913	Walter MacFarlane & Co, Saracen Foundry, Glasgow	279
Birkenhead	Birkenhead Park	Lost			
Birkenhead	Birkenhead Park	Existing	1847		
Birmingham	Botanical Gardens	Existing	1873		
Birmingham	Handsworth Park	Existing	1903	Lion Foundry Co Ltd, Kirkintilloch	23
Birmingham	Lightwoods Park, Smethwick	Existing	1903	Lion Foundry Co Ltd, Kirkintilloch	23
Birmingham	Calthorpe Park	Lost			
Birmingham	Summerfield Park	Existing	1892		
Birmingham	Pype Hayes Park	Lost			
Birmingham	Kings Norton Park	Lost			
Birmingham	King's Heath Park	Lost			
Birmingham	Edgbaston Reservoir	Lost			
Birmingham	Warley Woods	Lost			
Birmingham	Cannon Hill Park	Existing	1895	Hart, Son, Peard and Co.	
Birmingham	Small Heath Park	Existing	1887	Yates & Haywood, Rotherham	
Blackburn	Corporation Park	Lost			
Blackburn	Sunnyhurst Woods	Lost			
Blackburn	Queens Park	Lost	1909	Lion Foundry Co Ltd, Kirkintilloch	23
Blackpool	South Pier	Lost	1893		
Blackpool	Promenade	Existing	1994		
Blackpool	Stanley Park	Existing	1929		
Blaenau Festiniog	Gardens	Lost			
Blandford	The Ham		c.1950		
Bletchley	Town Centre	Existing			
Bloxwich, W.Midlands	Bloxwich Park	Lost			
Blyth	Sea front	Existing	1928		
Blyth	Ridley Park	Lost			
Bodmin	Priory Park	Existing	c.1950		
Bognor Regis	Esplanade (Eastern End)	Existing	1948	Walter MacFarlane & Co, Saracen Foundry, Glasgow	249
Bognor Regis	Hotham Park	Existing	1951		
Bognor Regis	Esplanade (Western End)	Lost	1901		
Bognor Regis	Esplanade (Western End)	Lost	1937		
Bognor Regis	Esplanade (Eastern End)	Lost	1910		
Bolton	Victoria Square	Existing	1984		
Bolton	Farnworth Park	Lost			
Bolton	Queens Park	Lost			
Bo'ness	Glebe Park	Existing	1901	Walter MacFarlane & Co, Saracen Foundry, Glasgow	279
Bootle	Derby Park	Existing	1899		
Boscombe	Fishermans Walk Gardens (on the Cliff)	Existing			
Boscombe	Fishermans Walk Gardens	Existing	1924		
Boscombe	Crescent Gardens	Lost			
Bournemouth	Invalid's Walk / Pine Walk	Lost			
Bournemouth	Pier	Lost	1885		
Bournemouth	Central Gardens (aka Pine Walk)	Existing	1933		
Bowness on Windermere	The Glebe	Existing	2005		
Bowness, Falkirk	Glebe Park	Existing	1901	Walter MacFarlane & Co, Saracen Foundry, Glasgow	
Bracknell	Charles Square	Existing	c.1960		
Bradford	Bowling Park	Lost			
Bradford	Horton Park	Lost			
Bradford	Lister Park	Existing	1904		
Bradford	Peel Park	Lost			
Bradford	Roberts Park	Lost			
Bradford	Roberts Park	Existing	2010		
Braintree	Public Gardens	Existing	1888		
Brechin	Brechin Park	Existing	1908	Walter MacFarlane & Co, Saracen Foundry, Glasgow	225
Brentwood	Shenfield Common	Lost			
Bridgnorth	Castle Gardens	Existing	1897		
Bridgwater	Blake Gardens	Existing	1908		
Bridlington	The Spa	Existing			
Bridlington	Sewerby Hall	Existing	1997	Ollerton	
Bridlington	Prince's Parade	Lost			
Bridlington	Sewerby Hall	Lost			
Brighton	Palace Pier	Lost	1911		
Brighton	The Aquarium	Lost	1880s		
Brighton	West Pier	Lost	1881		
Brighton	West Pier, Birdcage	Existing	1884	Walter MacFarlane & Co, Saracen Foundry, Glasgow	
Brighton	Old Steine	Lost			
Brighton	Royal Pavilion	Lost			
Bristol	Page Park	Existing	1931		
Bristol	Castle Park	Existing	c.1980		
Bristol	Brislington Park	Lost			
Bristol	Ashton Park	Lost			
Bristol	St Andrews Park	Lost	1899		
Bristol	Greville Smyth Park	Lost			
Bristol	Exhibition /Dominions Pavilion	Lost			
Bristol	Sparke Evans Park	Existing			
Bristol	Dean Lane/Dame Emilys play park	Lost			
Bristol	Zoo Gardens, Clifton	Lost			
Broadstairs	Victoria Gardens	Existing	1952		
Broadstairs	Sea front	Lost		Walter MacFarlane & Co, Saracen Foundry, Glasgow	279
Bromsgrove	Sanders Park	Existing	2002	Andy Thornton	
Bude	Castle Grounds	Existing	1947		

Location	Park	Status	Date	Manufacturer	Ref
Burgess Hill	Church Walk	Lost	1992		
Burnham on Sea	Public Gardens, Manor Park	Existing	1995	Ollerton	
Burnham on Sea	Promenade	Lost	1902		
Burnley	James Street	Existing	1989	Heritage Nouveau	
Burnley	Padiham Memorial Park	Lost	1927		
Burnley	Townley Park	Lost	1929		
Burnley	Queens Park	Lost	1893	Walter MacFarlane & Co, Saracen Foundry, Glasgow	249
Burnley	Scott Park	Existing	1895	Walter MacFarlane & Co, Saracen Foundry, Glasgow	249
Burton upon Trent	Stapenhill Gardens	Existing			
Burton upon Trent	Eton Community Park	Existing			
Burton upon Trent	Outwards Recreation Ground	Lost			
Burton upon Trent	Stapenhill Recreation Ground	Lost			
Bury	Clarence Park	Existing	2005	Ollerton	
Bury	Clarence Park aka Walmersley Road	Lost		McDowall, Steven & Co, Milton Ironworks, Glasgow	
Buxton	Pavilion Gardens	Lost	1871	McDowall, Steven & Co, Milton Ironworks, Glasgow	
Buxton	Pavilion Gardens	Existing	1997	Leander Architectural	
Buxton	Sylvan Gardens	Lost			
Buxton	Municipal Gardens	Lost			
Buxton	Ashwood Park	Lost			
Caerphilly	Castle Court Shopping Centre	Existing	1995		
Camelford	Enfield Park	Existing			
Cannock	Town Centre	Existing			
Canterbury	Dane John Gardens	Existing	1999	Walter MacFarlane & Co, Saracen Foundry, Glasgow	279
Cardiff	Victoria Park	Existing	1996	Walter MacFarlane & Co, Saracen Foundry, Glasgow	
Cardiff	Grange Gardens	Existing	2000	Laings Foundry, originally MacFarlane	
Cardiff	Roath Park	Lost	1903		
Cardiff	Splott Park	Lost	1905		
Cardigan	Victoria Gardens	Existing	1897		
Carlisle	Victoria Park (Bitts Park)	Lost		Walter MacFarlane & Co, Saracen Foundry, Glasgow	279
Carmarthen	Recreation Ground	Lost			
Carmarthen	Carmarthen Park	Existing	1900	Lion Foundry Co Ltd, Kirkintilloch	37
Carnoustie, Angus	The Links	Lost			
Carrick	Gyllyngdune Gardens	Existing			
Castleford	Queens Park	Existing	1910	Walter MacFarlane & Co, Saracen Foundry, Glasgow	
Chatham	Victoria Gardens	Existing	1897	Walter MacFarlane & Co, Saracen Foundry, Glasgow	279
Chatteris	Market Square	Existing		Ollerton	
Chelmsford	Recreation Ground	Lost			
Cheltenham	Sandford Park	Lost			
Cheltenham	Winter Gardens	Lost	1920	Walter MacFarlane & Co, Saracen Foundry, Glasgow	249
Cheltenham	Pittville Park	Existing	1900		
Cheltenham	Montpellier Gardens	Existing	1864	J. Butt / Coalbrookdale, Gloucester/Coalbrookdale	
Chepstow	Riverside Gardens	Existing	1988	Ollerton	
Chester	River Dee, the Groves	Existing	1882	Lion Foundry Co Ltd, Kirkintilloch	
Chesterfield	Queens Park	Existing	1894	Walter MacFarlane & Co, Saracen Foundry, Glasgow	249
Chippenham	John Coles Park	Existing	1955		
Chipping Camden	Hidcote	Existing	c.1910		
Chiswick	Dukes Meadow	Existing			
Christchurch	Town Quay	Existing	1901	Lion Foundry Co Ltd, Kirkintilloch	24
Church Gresley	Maurice Lea Memorial park	Existing	1929	Hill & Smith Ltd, Brierley Hill, W. Midlands	
Cirencester	Abbey Grounds	Existing	2000	Ollerton	
Clacton on Sea	Sea front	Lost		Walter MacFarlane & Co, Saracen Foundry, Glasgow	279
Clacton on Sea	East Cliff	Lost		Walter MacFarlane & Co, Saracen Foundry, Glasgow	279
Cleethorpes	Lakeside	Existing		Ollerton	
Clevedon	Sea front	Existing	1887	James Allan & Co, Elmbank Foundry	
Cliftonville	The Oval	Existing			
Cliftonville	The Fort	Lost		Walter MacFarlane & Co, Saracen Foundry, Glasgow	249
Cliftonville	The Oval	Lost		Walter MacFarlane & Co, Saracen Foundry, Glasgow	224
Clitheroe	Castle Grounds	Existing	1923		
Clough	Boggart Hole	Lost			
Clydebank	Clyde Retail Park, Three Queens Square	Existing	1906	Lion Foundry Co Ltd, Kirkintilloch	25
Colchester	Castle Park	Existing	1892	Walter MacFarlane & Co, Saracen Foundry, Glasgow	249
Colne	Alkincoats Park	Existing			
Colwyn Bay	Promenade, Eastern end	Lost			
Colwyn Bay	Eirias Park	Lost			
Colwyn Bay	Pier	Lost	1934		
Compstall	Athanaeum	Lost			
Congleton	Town Park	Existing	1913	Hill & Smith Ltd, Brierley Hill, W. Midlands	
Consett	Blackhill Park	Existing	1891		
Corby	Corporation Street	Existing	1995		
Coventry	Naul's Mill Park	Lost		Hill & Smith Ltd, Brierley Hill, W. Midlands	
Coventry	Gosford Green Park	Lost		Walter MacFarlane & Co, Saracen Foundry, Glasgow	279

Town	Park	Status	Date	Manufacturer	No.
Crawley	Queens Square	Existing	1891		
Crediton	Newcombes Meadow	Existing	1999		
Creswell, Bolsover	The Park	Lost			
Crewe	Queens Park	Existing	c.1900		
Crewe	Queens Park	Existing	1887	W.A. Baker & Sons, Newport, Monmouthshire	
Crich	Tramways Museum	Existing	c.1900	Parnall & Sons	
Cricklewood	Gladstone Park	Lost			
Crieff	Macrosty Park	Existing	1907	James Allan & Co, Elmbank Foundry	
Cross Keys	Waunfawr Park	Existing		W.A. Baker & Sons, Newport, Monmouthshire	
Croydon	Wandle Park	Existing		Walter MacFarlane & Co, Saracen Foundry, Glasgow	224
Croydon	Grangewood Park	Lost			
Croydon	Beckenham Rec	Existing		McCallum & Hope, Ruchill Ironworks, Glasgow	
Croydon	Park Hill	Lost			
Cudworth	Miners Welfare Park	Lost			
Cupar	Haugh Park	Existing	1924	Walter MacFarlane & Co, Saracen Foundry, Glasgow	279
Cwmbran	Gwent Square	Existing	1972		
Dalbeattie	Colliston Park	Existing	1900	Lion Foundry Co Ltd, Kirkintilloch	
Darlaston	George Rose Park	Existing	c.1935	Hill & Smith Ltd, Brierley Hill, W. Midlands	
Darlington	South Park	Existing	1893	Walter MacFarlane & Co, Saracen Foundry, Glasgow	279
Darlington	North Park	Existing	1903	Walter MacFarlane & Co, Saracen Foundry, Glasgow	
Darlington	North Lodge Park	Existing	1903	McDowall, Steven & Co, Milton Ironworks, Glasgow	
Dartford	Central Park	Lost		Walter MacFarlane & Co, Saracen Foundry, Glasgow	279
Dartmouth	Quayside Gardens / Riverside Park	Existing	1911	Lion Foundry Co Ltd, Kirkintilloch	24
Darwen	Whitehall Park	Lost		Walter MacFarlane & Co, Saracen Foundry, Glasgow	249
Darwen	Bold Venture Park	Lost		Walter MacFarlane & Co, Saracen Foundry, Glasgow	249
Darwen	Sunnyhurst Woods	Lost			
Dawdon	Green Drive	Lost			
Dawlish	The Lawn	Existing	c.1960		
Deal	Sea Front	Existing	1993		
Denaby	Memorial Park	Existing	1998	Ollerton	
Denholme	Foster Park	Existing	1922		
Denton	Victoria Park	Existing	1907	Hill & Smith Ltd, Brierley Hill, W. Midlands	
Derby	Rosehill Recreation Ground	Lost			
Derby	Arboretum	Existing			
Devonport	The Park	Lost			
Dewsbury	Crow Nest Park	Lost			
Dinnington	Recreation Ground	Lost			
Doncaster	Hexthorpe Flatts	Lost	1929		
Doncaster	The Dell	Lost			
Doncaster	Bentley Park	Lost			
Doncaster	Cusworth Hall	Existing			
Donnington	Flinders Park	Existing			
Dorchester	Borough Gardens	Existing	1898	Walter MacFarlane & Co, Saracen Foundry, Glasgow	
Dover	Pencester Gardens	Existing	2000		
Dover	Granville Gardens	Lost		Walter MacFarlane & Co, Saracen Foundry, Glasgow	279
Dovercourt	Cliff Gardens	Existing	1911		
Droitwich Spa	St Peters Field	Existing			
Droitwich Spa	Lido Park	Existing	1899	Russell of Leicester	
Dublin	Dun Laoghaire, Dublin Port	Existing		Walter MacFarlane & Co, Saracen Foundry, Glasgow	279
Dudley	Grange Park	Existing	1888		
Dumfries	Dock Park	Existing	1896	Walter MacFarlane & Co, Saracen Foundry, Glasgow	279
Dundee	Magdalene Green	Existing	1889	Walter MacFarlane & Co, Saracen Foundry, Glasgow	225
Dunedin	Botanic Gardens	Existing			
Dunfermline	Sinclair Gardens	Existing	1887	Walter MacFarlane & Co, Saracen Foundry, Glasgow	225
Dunfermline	Public Park	Lost			
Dunfermline	Pittencrieff Park / Glen	Lost	1927		
Dungarvan	Park	Lost			
Dunoon	Castle Gardens	Lost			
Dunoon	Argyll Gardens	Existing	1993	Heritage Nouveau	
Dunstable	Priory Gardens	Existing			
Durham City	Old Elvet Gardens	Existing	1992		
Durham City	Wharton Park	Existing	c.1920		
Durham City	Race Course	Lost			
Easingwold	Memorial Park	Existing	c.1920		
East Cowes, IoW	Esplanade	Lost			
East Croydon	Park Hill	Lost			
East Dumbartonshire	Peel Park	Existing			
Eastbourne	The Pier	Lost			
Eastbourne	Royal Parade	Lost			
Eastbourne	Grand Parade	Lost	1893		
Eastbourne	Grand Parade	Existing	1935		
Eastbourne	Redoubt Gardens	Lost			
Eastbourne	Redoubt Gardens	Existing	c.1930s		
Eastleigh	Town Gardens	Existing	1923	David Rowell / Lion Foundry	
Ecclesfield	Ecclesfield Park	Existing	c.1910		
Edinburgh	Scottisn National Exhibition Centre	Lost			
Edinburgh	Saughton Park	Lost	1908	Lion Foundry Co Ltd, Kirkintilloch	23

Edinburgh	Princes Street Gardens	Lost	1900	Walter MacFarlane & Co, Saracen Foundry, Glasgow	
Edinburgh	Princes Street Gardens	Existing	1935		
Edinburgh	The Meadows	Lost	1908	Lion Foundry Co Ltd, Kirkintilloch	23
Egremont	School of Art, Central Park Gardens	Lost			
Ellesmere	Cremorne Gardens	Existing	1953		
Elsecar	Elsecar Park	Existing	1930	Yates & Haywood, Rotherham	
Ely	Jubilee Gardens	Existing	2002		
Enfield	Pymmes Park	Existing			
Enfield	Ponders End Recreation Ground	Existing	c.1935		
Enfield	Hillyfields	Existing	c.1920		
Evesham	Abbey Park	Existing	1920		
Evesham	Workman Gardens	Lost			
Exeter	Northernhay Gardens	Existing	c.1910		
Exmouth	Manor Gardens	Existing	2004		
Exmouth	Manor Gardens	Lost		Hill & Smith Ltd, Brierley Hill, W. Midlands	
Exmouth	Beach Gardens	Lost			
Fairmilehead	Comiston Road	Lost			
Falkirk	Glebe Park	Existing			
Falkirk	High Street	Existing	1994	Ollerton	
Falmouth	Gyllyndune Gardens	Existing	1907	Walter MacFarlane & Co, Saracen Foundry, Glasgow	279
Fareham	West Street	Existing	2000		
Farnham	Gostrey Meadow	Existing			
Faversham	Park	Lost			
Felixstowe	Model Yacht Pond	Lost			
Filey	Sea front	Existing	1997	Ollerton	
Folkestone	Upper Leas	Lost	c.1890s	Walter MacFarlane & Co, Saracen Foundry, Glasgow	279
Folkestone	Marine Gardens	Lost	c.1890s		
Folkestone	The Leas	Existing	1895	James Allan Sen & Son, Elmbank Foundry	
Forfar	Reid Park	Existing	1900	Walter MacFarlane & Co, Saracen Foundry, Glasgow	
Frome	Victoria Park	Existing	1924		
Gateshead	Saltwell Park	Lost		Walter MacFarlane & Co, Saracen Foundry, Glasgow	279
Gateshead	Saltwell Park	Existing	1935	Hill & Smith Ltd, Brierley Hill, W. Midlands	
Gelli (Rhondda)	Gelli Park	Existing	1919	Hill & Smith Ltd, Brierley Hill, W. Midlands	
Gillingham	Garrison Sports Ground, Great Lines	Lost	c.1903		
Gillingham	Prince of Wales Bastion, Chatham Lines	Lost	c.1903		
Gillingham	The Strand	Lost	c.1930		
Gillingham	Gillingham Park	Lost	1906		
Girvan	Stair Park	Existing	c.1907		
Glasgow	Bellahouston Park Ski Centre	Existing	c.1925		
Glasgow	Tollcross Park	Existing		Ollerton	
Glasgow	Alexandra Park	Lost			
Glasgow	Kelvingrove Park	Lost			
Glasgow	Phoenix Park	Lost	1894	James Allan Sen & Son, Elmbank Foundry	
Glasgow	Springburn Park	Lost	1891	Walter MacFarlane & Co, Saracen Foundry, Glasgow	
Glasgow	Elder Park, Govan	Lost	1903	Lion Foundry Co Ltd, Kirkintilloch	24
Glasgow	Linn Park	Lost			
Glasgow	Govanhill	Lost			
Glasgow	Overtoun Park	Existing	1914	Walter MacFarlane & Co, Saracen Foundry, Glasgow	296
Glasgow	Queens Park	Existing	c.1925		
Glasgow	Queens Park	Lost		Walter MacFarlane & Co, Saracen Foundry, Glasgow	
Glasgow	Kelvingrove Park	Existing	1924		
Gloucester	Gloucester Park	Existing			
Gloucester	The Park	Lost	1934		
Godalming	Philips Memorial Ground	Existing			
Godalming	The Burgs	Existing	2006		
Goole	Riverside Gardens	Existing	1927		
Goole	West Park	Existing	1923	David Rowell, London	
Grange over Sands	Park Road Gardens	Existing	1892	J & A Law, Glasgow	
Grangemouth	Public Park	Lost			
Grangewood	Park	Lost			
Grantham	Dysart Park	Existing	c.1920		
Gravesend	Fort Gardens	Existing	1932	Walter MacFarlane & Co, Saracen Foundry, Glasgow	
Gravesend	Promenade	Lost			
Grays, Essex	Park	Lost			
Great Malvern	Priory Park	Existing	1875	Walter MacFarlane & Co, Saracen Foundry, Glasgow	249
Great Yarmouth	Gorleston	Existing	c.1970		
Great Yarmouth	Pavilion, Wellington Gardens	Lost	1900		
Great Yarmouth	Pavilion, Wellington Gardens	Lost	1921		
Greenock	Battery Park	Lost	1924	Lion Foundry Co Ltd, Kirkintilloch	24
Grimsby	People's Park	Existing	1995	CI Workshop	
Grimsby	Alexandra Dock	Existing	1923	David Rowell, London	
Grimsby	The Park	Lost			
Guernsey	Candie Gardens Museum	Existing		Walter MacFarlane & Co, Saracen Foundry, Glasgow	
Guildford	Castle Grounds	Existing	1888		
Halifax	Piece Hall	Existing	1990		

Location	Park	Status	Date	Foundry	Ref
Halifax	People's Park	Existing	1897	Dougill & Co Ltd. Leeds	
Halstead	Halstead Public Gardens	Existing	1901		
Hamilton	Public Park, Bothwell Road	Existing	1912	Walter MacFarlane & Co, Saracen Foundry, Glasgow	279
Hampstead	Highgate Park	Existing			
Harborne, Birmingham	Queens Park	Lost			
Hardraw Scar	Falls	Existing	c.1930		
Haringey	Lordship Recreation Ground	Existing			
Harlesden	Roundwood Park	Lost		Walter MacFarlane & Co, Saracen Foundry, Glasgow	249
Harlow	Town Park	Existing	c.1960		
Harrogate	West Park Stray	Lost			
Harrogate	Spa Gardens	Lost			
Harrogate	Harlow Moor	Lost			
Harrogate	Crescent Gardens	Lost			
Harrogate	Valley Gardens	Lost		Walter MacFarlane & Co, Saracen Foundry, Glasgow	279
Harrogate	Valley Gardens	Existing	1933		
Hartlepool	Jackson Dock	Existing	1997	Ollerton	
Hartlepool	The Promenade	Lost		Walter MacFarlane & Co, Saracen Foundry, Glasgow	279
Hartlepool	Ward Jackson Park	Existing	1901	J&A Law, Rae Street, Glasgow	
Harwich	Cliff Park	Existing			
Haslingden	Victoria Park	Existing	1901		
Haslingden	Victoria Park	Lost			
Hastings	Sea Front, White Rock	Lost	1883		
Hastings	Warrior Square	Lost	1874		
Hastings	Caroline Place	Lost	1912		
Hastings	Promenade	Lost	c.1890s	McDowall, Steven & Co, Milton Ironworks, Glasgow	
Hastings	Alexandra Park	Existing	1902		
Hatcham	Pepys Road Recreation Ground	Lost			
Hathersage	Pool	Existing	c.1910	Walter MacFarlane & Co, Saracen Foundry, Glasgow	279
Haverhill	Recreation Ground	Existing	2000	Ollerton	
Hawick	Wilton Lodge Park	Lost	1890	McDowall, Steven & Co, Milton Ironworks, Glasgow	
Haworth	Haworth Park	Lost	1937	Hill & Smith, Brierley Hill, W. Midlands	
Hayes	Barra Hall Park	Existing	1924	Hill & Smith, Brierley Hill, W. Midlands	
Heckmondwike	Green Park	Existing	2006		
Helensburgh	Kidston Park	Existing	1877		
Hemel Hempstead	The Marlowes	Existing	2005		
Henley on Thames	Mill Meadows	Existing	2002		
Hereford	Redcliffe Gardens	Existing	1969		
Herne Bay	East Cliff Pavilion	Lost		Walter MacFarlane & Co, Saracen Foundry, Glasgow	249
Herne Bay	Tower Gardens, CentralParade	Existing	1924		
Hexham	Hexham Parks	Existing	1912	Walter MacFarlane & Co, Saracen Foundry, Glasgow	249
Heywood	Queen's Park	Existing	c.1950		
Hinckley	Hollycroft Park	Existing	1934		
Hindley	Leyland Park	Existing	c.1935		
Hitchin	Bancroft Recreation Ground	Existing	1929		
Holywell	Greenfield Valley Park	Existing	1994	Ollerton	
Hordern	Welfare Park	Existing	1928	Hill & Smith, Brierley Hill, W. Midlands	
Horsham	Horsham Park	Existing	1930		
Horsham	Carfax, Town Centre	Existing	1892	Walter MacFarlane & Co, Saracen Foundry, Glasgow	279
Hove	St Anne's Wells Gardens	Lost		Walter MacFarlane & Co, Saracen Foundry, Glasgow	279
Hove	Western Lawns	Lost		Walter MacFarlane & Co, Saracen Foundry, Glasgow	279
Hoylake	Front	Lost			
Huddersfield	Beaumont Park	Existing			
Huddersfield	Greenhead Park	Existing	1884		
Hull	West Park	Lost			
Hull	Pearson Park	Lost			
Hunstanton	The Green	Existing	1994		
Huntingdon	Town Park	Existing	1997	A J Bernasconi	
Hyde, Tameside	Hyde Park	Existing	1922	Lion Foundry Co Ltd, Kirkintilloch	23
Hythe	Oaklands Gardens	Existing			
Hythe	Memorial Gardens	Lost			
Ilfracombe	Runnymede Gardens	Existing	1990	Ollerton	
Ilfracombe	Capstone Parade	Lost	1894	Walter MacFarlane & Co, Saracen Foundry, Glasgow	249
Ilkeston	Victoria Park	Existing	1923	Hill & Smith, Brierley Hill, W.Midlands	
Ilkley	The Grove	Existing	2001	Andy Thornton	
Ilkley	West View Park	Lost			
Inverness	Bellfield Park	Existing	2000		
Ipswich	Christchurch Park	Lost		Walter MacFarlane & Co, Saracen Foundry, Glasgow	249
Irlam, Salford	Princess Park	Lost	1926	Lion Foundry Co Ltd, Kirkintilloch	
Irvine	Riverside Centre	Existing	2004	Ollerton	
Isle of Man	Villa Marina Gardens	Existing			
Isle of Man	Laxey Glen Gardens	Lost			
Jarrow	West Park	Existing	1925	David Rowell, London	
Jedburgh	TIC, Murrays Green	Existing	2006		
Johnstone, Renfrewshire	Houston Square	Existing	1891	Murdoch & Cameron	
Keighley	Lund Park	Lost		George Smith & Co, Sun Foundry, Glasgow	
Keighley	Cliff Castle Park	Existing	c.1968		

Keighley	Devonshire Park	Lost			
Keighley	Victoria Park	Lost		Walter MacFarlane & Co, Saracen Foundry, Glasgow	249
Keith	St Rufus Gardens	Existing	1947		
Kendal	Town Centre	Existing			
Kettering	Rockingham Road Park	Existing	1931	Hill & Smith, Brierley Hill, W. Midlands	
Kettering	Wicksteed Park	Lost			
Keynsham	Memorial Park	Existing	1962	Paul Campbell	
Kidderminster	Brinton Park	Existing	1934		
Kilmarnock	Kay Park	Lost	1879		
Kilmarnock	Howard Park	Existing	c.1920		
Kilsyth	Burngreen Peace Park	Existing	1910	Lion Foundry Co Ltd, Kirkintilloch	37
Kings Lynn	The Walks	Existing	1923		
Kingsbridge	The Quay	Existing	1998		
Kingston upon Thames	Canbury Gardens	Existing	1997		
Kirkcaldy	Beveridge Park	Lost			
Kirkintilloch	Woodhead Park	Existing	c.1950		
Kirkintilloch	Woodhead Park	Lost	1931	Lion Foundry Co Ltd, Kirkintilloch	25
Kirkintilloch	Peel Park	Existing	1905	Lion Foundry Co Ltd, Kirkintilloch	25
Knaresborough	Castle Grounds	Lost			
Lambeth	Myatt's Fields	Existing			
Lanarkshire	Strathaven Park	Lost			
Lancaster	Williamson Park	Existing	1909		
Lancaster	Ryelands Park	Existing	1911		
Langold	Country Park	Existing	c.1950		
Larne	Dixon Park	Existing			
Leamington Spa	Pump Room Gardens	Existing	1896	Walter MacFarlane & Co, Saracen Foundry, Glasgow	224
Leamington Spa	Victoria Park	Lost	1910		
Leamington Spa	Eagle Road Rec	Lost	1932		
Leamington Spa	Jephson Gardens	Lost	1850		
Leamington Spa	Jephson Gardens	Lost	1880		
Leamington Spa	Jephson Gardens	Lost	1909		
Leeds	Middleton Park	Lost	1924		
Leeds	Cross Flatts Park	Lost	1899	McDowall, Steven & Co, Milton Ironworks, Glasgow	
Leeds	East End Park	Lost	c.1886	Walter MacFarlane & Co, Saracen Foundry, Glasgow	
Leeds	Roundhay Park	Lost	c.1890	McDowall, Steven & Co, Milton Ironworks, Glasgow	
Leeds	Dartmouth Park, Morley	Lost	c.1890		
Leeds	Bramley Park	Lost	c.1872	Walter MacFarlane & Co, Saracen Foundry, Glasgow	249
Leeds	Chapeltown Rec	Lost	c.1900	Walter MacFarlane & Co, Saracen Foundry, Glasgow	279
Leeds	North Street Rec Ground	Lost	1906	McDowall, Steven & Co, Milton Ironworks, Glasgow	
Leeds	Burley Park	Lost		McDowall, Steven & Co, Milton Ironworks, Glasgow	
Leeds	Rodley Park	Lost	c.1890	Walter MacFarlane & Co, Saracen Foundry, Glasgow	279
Leeds	Woodhouse Moor	Lost	1879		
Leeds	Wharfe Meadows, Otley	Lost			
Leeds	Western Flatts Park, Wortley	Lost	1928	McDowall, Steven & Co, Milton Ironworks, Glasgow	
Leeds	Wortley Recreation Ground	Lost	c.1905		
Leeds	Woodhouse Ridge	Lost	c.1905	Hill & Smith, Brierley Hill, W. Midlands	
Leeds	Horsforth Hall Park	Existing			
Leeds	Kirkstall Abbey	Lost			
Leeds	Armley Park	Lost	c.1928		
Leeds	Yeadon Tarn	Existing	2000		
Leek	Brough Park	Existing	1924		
Leicester	St Martin's Square	Existing	1990	Dorothea	
Leicester	Abbey Park	Existing	1908	Ellgood	
Leicester	Western Park	Existing	1899		
Leicester	Victoria Park	Existing			
Leigh	Church Street Gardens	Lost			
Leighton Buzzard	Parsons Recreation Ground	Existing	c.1930		
Leith	Victoria Park	Lost		Walter MacFarlane & Co, Saracen Foundry, Glasgow	
Leith	Links	Lost		Walter MacFarlane & Co, Saracen Foundry, Glasgow	279
Lichfield	Recreation Grounds	Lost			
Limerick	People's Park	Existing	1895	Lion Foundry Co Ltd, Kirkintilloch	14
Lincoln	Boultham Park	Existing	1935	Hill & Smith, Brierley Hill, W. Midlands	
Lincoln	Temple Gardens and Arboretum	Existing	1884	George Smith, Sun Foundry, Glasgow	
Lisburn	Wallace Park	Existing			
Littleborough	Harehills Park	Existing	1902	Walter MacFarlane & Co, Saracen Foundry, Glasgow	
Littlehampton	Sea Front	Lost			
Littlehampton	Sunken Gardens	Lost			
Liverpool	Pier Head	Existing	1995		
Liverpool	Sefton Park	Existing	1890	Hill & Smith, Brierley Hill, W. Midlands	
Liverpool	Stanley Park	Existing	1890	Walter MacFarlane & Co, Saracen Foundry, Glasgow	279
Liverpool	Walton Hall Park	Lost			
Liverpool	Newsham Park	Existing			
Llandeilo	Penlan Park	Existing	c.1910		
Llandrindod Wells	Spa Road	Existing	c.1980		

Location	Park	Status	Date	Maker	
Llandudno	The Parade	Existing	1926		
Llanelli	People's Park	Existing	c.1950		
Llanelli	Parc Howard	Existing	1912	David Rowell, London	
Llangollen	Riverside Park	Existing	1991		
London	Golders Hill Park	Existing	1905		
London	Queen's Park, Brent	Existing	1887	Walter MacFarlane & Co, Saracen Foundry, Glasgow	279
London	Oak Hill Park, Barnet	Existing	1935		
London	Bishops Park, Fulham	Lost			
London	Bostall Heath, Greenwich	Lost			
London	Barking Park, East Street	Existing	1991		
London	Crystal Palace Park, Bromley	Existing	1997		
London	Brockwell Park	Lost			
London	The Promenade, Chiswick	Existing	1926		
London	East Ham, Central Park	Lost	1903	Lion Foundry Co Ltd, Kirkintilloch	
London	Woodgreen Recreation Ground	Lost			
London	The Downs, Hackney	Lost			
London	Beckton Road Park	Lost			
London	South Park Gardens, Merton	Lost			
London	Southwark Park	Existing	2002	George Smith / Dorothea	
London	Morden Park	Existing	c.1950		
London	Roundwood Park	Existing	1959		
London	Manor Park, Sutton	Lost			
London	Seven King's Park, Ilford	Existing	c.1920		
London	Broomfield Park, Palmer's Green	Existing	1926		
London	Hornsey Gardens	Lost			
London	Kings Edward Memorial Park	Existing	1992	Ollerton	
London	Mountsfield Park	Existing	c.1920		
London	The Spires, High Barnet	Existing	1990		
London	Ferranti Park, Lewisham	Existing			
London	Telegraph Hill Park, Hatcham	Lost			
London	Northampton Square	Existing	1930		
London	Vauxhall Gardens, East Lambeth Road	Lost	1912	Lion Foundry Co Ltd, Kirkintilloch	
London	John Innes Park, Merton	Existing	1907		
London	Maryon Park, Old Charlton	Lost			
London	Victoria Embankment Gardens	Lost		McDowall, Steven & Co, Milton Ironworks, Glasgow	
London	Wanstead Flatts	Lost			
London	Churchhouse Gardens, Bromley	Existing	c.1950		
London	Finsbury Park	Lost			
London	Gabriel's Walk	Existing	1988		
London	Regent's Park	Existing	1931		
London	Plashet Park	Lost			
London	Central Park, Newham	Lost			
London	Coronation Gardens, Leyton	Existing	1903	Walter MacFarlane & Co, Saracen Foundry, Glasgow	279
London	Victoria Park	Existing	1990		
London	Erith Recreation Ground	Lost			
London	Gladstone Park, Brent	Lost			
London	Town Park, Enfield	Lost			
London	Island Gardens, Millwall	Lost			
London	Lloyds Park, Walthamstow	Lost			
London	The Green, Enfield	Lost		Walter MacFarlane & Co, Saracen Foundry, Glasgow	279
London	Waterlow Park, Highgate	Lost			
London	Franks Park, Belvedere, Bexley	Lost			
London	Clissold Park, Stoke Newington	Existing	c.1950		
London	Elthorne Park, Ealing	Existing	1910		
London	Clissold Park, Stoke Newington	Lost			
London	Peckham Rye	Lost			
London	Greenwich Park	Existing	1880	Deane & Co	
London	Kensington Gardens	Existing	1931		
London	Lammas Park	Lost			
London	Crystal Palace	Lost		Lion Foundry?	
London	Ravenscourt Park	Lost			
London	Valentines Park	Existing	1900	Baylis Jones & Baylis	
London	Upper Norwood Recreation Ground	Lost		Walter MacFarlane & Co, Saracen Foundry, Glasgow	224
London	Hyde Park	Existing	1869		
London	Southall Park	Lost			
London	Horniman Gardens	Existing	1904		
London	Arnold Circus	Existing	1909		
London	The Gardens, Hornsey	Lost			
London	Raphael Park, Romford	Existing	1904		
London	Myatt's Fields	Existing	1889		
London	Kneller Hall, Twickenham	Existing	1996		
London	West Ham Park	Existing	1883		

Location	Park	Status	Date	Maker	No.
London	Pymmes Park, Edmonton	Lost		Walter MacFarlane & Co, Saracen Foundry, Glasgow	279
London	Hampstead Heath	Existing			
London	Highbury Grove School	Existing	1993		
London	Springfield Park, Hackney	Existing	c.1910		
London	Canning Town Recreation Ground	Lost			
London	Ropemakers Fields	Existing	1994		
London	Hermir Road Recreation Ground	Lost			
London	Little Ilford Park	Lost			
London	Stratford Park	Lost			
London	Highbury Fields	Existing			
London	Grovelands Park	Existing			
London	Richmond Terrace	Lost			
London	King George's Park, Wandsworth	Lost	1938		
London	Richmond Park	Lost			
London	Royal Victoria Gardens	Lost			
London	Parliament Hill	Existing	1986	Andy Thornton	
London	Kennington Park	Existing			
London	Lincolns Inn Fields	Existing			
London	Paddington Recreation Ground	Existing	1989		
London	Battersea Park	Existing	1987	Bandstands Ltd	
London	Clapham Common	Existing	1890	George Smith & Co. Sun Foundry, Glasgow	
London	Kenwood Park	Existing			
London	Finsbury Circus	Existing	1955		
London	Ruskin Park	Existing	1906		
London	Thornton Heath	Lost			
Long Eaton, Derbys.	West Park	Existing	1885	Walter MacFarlane & Co, Saracen Foundry, Glasgow	249
Longton	Queens Park	Existing	1889	Dean & Lowe	
Loughborough	Queens Park	Existing	1902	Hill & Smith, Brierley Hill, W. Midlands	
Loughborough	Carillon Tower	Existing			
Loughor	Parc Williams	Existing	1929		
Lowestoft	Sparrows Nest Park	Existing	1994		
Lowestoft	South Pier	Lost			
Lowestoft	Belle Vue Park	Lost			
Luton	Hoo Memorial Park	Lost			
Luton	Wardown Park	Lost		Walter MacFarlane & Co, Saracen Foundry, Glasgow	279
Lydney	Bathurst Park	Existing	1892		
Lymington	Bath Road Recreation Ground	Existing	2000	Ollerton	
Lymington	Banks	Lost		David Rowell, London	
Macclesfield	South Park	Lost			
Macclesfield	Victoria Park	Existing	1894	Walter MacFarlane & Co, Saracen Foundry, Glasgow	279
Macclesfield	West Park	Lost			
Macclesfield	South Park Gardens	Existing	1937		
Maidenhead	Bridge Gardens	Existing	c.1930		
Maidstone	Brenchley Gardens	Existing	1871		
Maidstone	Whatman Millennium River Park	Existing	2001		
Maidstone	Strood Recreation Grounds	Lost	1903	Lion Foundry Co Ltd, Kirkintilloch	23
Manchester	Alexandra Park	Lost		Walter MacFarlane & Co, Saracen Foundry, Glasgow	224
Manchester	Debdale Park	Lost			
Manchester	Philips Park	Lost			
Manchester	Hearon Park	Lost	1914		
Manchester	Helmet Street Recreation Ground	Lost			
Manchester	Debdale Park	Lost			
Manchester	Botanical Gardens	Lost	1887		
Manchester	Queen's Park	Lost			
Manchester	Chapel Street Park, Levenshulme	Lost			
Manchester	Cringle Fields	Lost			
Manchester	Platt Fields Park	Existing	1920s		
Manchester	Cheetham Park	Existing	1885		
Manchester	Hullard Park	Lost		Walter MacFarlane & Co, Saracen Foundry, Glasgow	225
Manchester	Longford Park	Lost			
Manchester	Corporation Street	Existing			
Manchester	Whitworth Park	Lost			
Manchester	Birchfields Park (Birch)	Lost			
Manchester	Angel Meadow	Lost			
Manchester	Peel Park	Lost	1887		
Mansfield	Berry Hill Park	Existing	c.1950		
Mansfield	Carr Bank Sculpture Park	Existing			
Mansfield	The Park	Lost			
Mansfield, Woodhouse	Yeoman Hill Park	Existing	c.1935		
March	Gaul Road Recreation Ground	Lost	1914-15		
March	Market Place	Existing			
Margate	Dane Park	Lost	c.1890s		
Margate	Cliftonville Oval	Existing	2008		
Margate	The Jetty	Lost	c.1890s		
Margate	The Fort	Lost	c.1890s	Walter MacFarlane & Co, Saracen Foundry, Glasgow	249
Market Harborough	Welland Park	Existing	1935		
Marsden	Marsden Park	Existing	1912		
Masbrough	Ferham Park	Lost	1887		
Matlock	The Leys	Existing	1914	Lion Foundry Co Ltd, Kirkintilloch	25

Matlock Bath	Derwent Gardens	Existing	1994		
Matlock Bath	Lovers Walk	Existing	1893		
Melton Mowbray	New Park	Existing	1887	Russell	
Merthyr Tydfil	Thomas Town Park	Lost			
Merthyr Tydfil	Cyfarthfa Park	Existing		Hill & Smith Ltd, Brierley Hill, W. Midlands	
Middlesbrough	Albert Park	Existing	2003	George Smith & Co. Sun Foundry, Glasgow	
Middlesbrough	Town Hall Gardens	Lost			
Middleton, Lancs	Jubilee Park	Existing	1890		
Milford Haven	The Rath	Existing	1992	Heritage Nouveau	
Milngarvie	Mugdock Park	Existing	2000		
Milton Keynes	Campbell Park	Existing			
Milton Keynes	Willen Lakeside Park	Existing	1987	Andy Thornton	
Minehead	Blenheim Gardens	Existing	1963		
Minehead	Jubilee Gardens	Existing	1935		
Montrose	Park	Lost			
Montrose	High Street, Town Centre	Lost			
Morecambe	Bare, Happy Mount Park	Lost			
Morecambe	West End Gardens				
Morley	Dartmouth Park	Existing	2000	Ollerton	
Mumbles	The Pier	Lost		David Rowell	
Murton	Rec Ground	Lost			
Musselburgh	Lewisvale Park	Existing	1913	Lion Foundry Co Ltd, Kirkintilloch	37
Nairn	The Links, Wallace Bandstand	Existing	1884	George Smith & Co. Sun Foundry, Glasgow	
Neath	Victoria Gardens	Existing	1898	James Allan Sen & Son, Elmbank Foundry	
Nelson	Victoria Park	Existing	1912		
New Brighton	Marine Park, Wallasey	Lost	1898	Walter MacFarlane & Co, Saracen Foundry, Glasgow	279
New Brighton	Victoria Gardens	Lost			
New Brighton	The Pier	Lost			
New Brighton	Liscard Central Park	Lost			
New Brighton	Vale Park	Existing	1927		
Newark	Castle Grounds	Existing	1911		
Newbiggin by the Sea	Promenade	Lost			
Newbiggin by the Sea	Bridge Street shopping area, Sea front	Existing	1993	Dorothea	
Newbury	Victoria Park	Existing	1934	Lion Foundry Co Ltd, Kirkintilloch	24
Newcastle u Lyme	Stubbs Walk	Lost		Walter MacFarlane & Co, Saracen Foundry, Glasgow	249
Newcastle u Lyme	Queens Gardens	Existing	c.1950		
Newcastle upon Tyne	Moor Park	Lost		Walter MacFarlane & Co, Saracen Foundry, Glasgow	
Newcastle upon Tyne	Leazes Park	Existing	2003	George Smith / Heritage Eng	
Newcastle upon Tyne	Town Moor	Lost		Walter MacFarlane & Co, Saracen Foundry, Glasgow	
Newcastle upon Tyne	Armstrong Park	Lost			
Newcastle upon Tyne	Nunsmoor Park	Lost	1895	Walter MacFarlane & Co, Saracen Foundry, Glasgow	279
Newcastle upon Tyne	Exhibition Park	Existing	1877	Walter MacFarlane & Co, Saracen Foundry, Glasgow	225
Newmarket	Coronation bandstand	Lost			
Newport	Bellevue Park	Existing	2006	Heritage Engineering, Glasgow	
Newquay	The Killacourt	Existing	c.1960		
Newquay	Trenance Gardens	Existing	c.1960		
Newton Abbott	Courtenay Park	Existing	1908	James Allan & Co, Elmbank Foundry	
Newtongrange	Public Park	Lost			
Newtonheath, Manchester	Brookdale Park	Existing	1900	Walter MacFarlane & Co, Saracen Foundry, Glasgow	
Normanton	Haw Hill Park	Lost	1906		
North Hykeham	Green	Existing			
North Shields	Northumberland Park	Lost			
Northampton	Abington Park	Existing	1897	Hill & Smith, Brierley Hill, W. Midlands	
Norwich	Sandys-Winsch Parks	Existing			
Norwich	Eaton Park	Existing	1928		
Norwich	Waterloo Park	Existing	1933		
Norwich	Mousehold Heath	Existing	1992		
Norwich	Chapelfield Gardens	Existing	1890		
Nottingham	Trent Embankment	Existing	c.1935		
Nottingham	Castle Gardens	Existing	2000		
Nottingham	Pennyfoot Street	Lost			
Nottingham	Lenton	Lost			
Nottingham	Radford	Lost			
Nottingham	Bulwell Forest	Lost			
Nottingham	Vernon Park	Lost			
Nottingham	Victoria Embankment	Lost			
Nottingham	Forest	Lost			
Nottingham	Arboretum	Existing	c.1907		
Nuneaton	Riversley Park	Existing	1907		
Oakham, Rutland	Cutts Close Recreation Ground	Existing	1948	Lion Foundry Co Ltd, Kirkintilloch	
Okehampton	Simmons Park	Existing	2007		
Oldham	Alexandra Park	Lost		Walter MacFarlane & Co, Saracen Foundry, Glasgow	249
Oldham	Alexandra Park	Existing	1993	Ollerton	
Olney	Emberton Country Park	Existing	c.1970		
Ormskirk	Coronation Park	Existing			
Oswestry	Cae Glas Park	Existing	1911	Walter MacFarlane & Co, Saracen Foundry, Glasgow	225
Oulton, Norfolk	Nicholas Everitt Park	Existing	c.1965		
Oxford	Florence Park	Existing	1936		
Paignton	Victoria Park	Lost	1938		
Paignton	Sea Front	Lost	1888		

Town	Park	Status	Year	Foundry	No.
Paisley	Maxwelton Park	Lost	1897		
Paisley	Brodie Park	Lost	1926	Lion Foundry Co Ltd, Kirkintilloch	
Palmers Green	Brookfield Park				
Palmers Green	Woodside Park	Existing			
Pateley Bridge	Recreation Ground	Existing	1998	Ollerton	
Penarth	Windsor Gardens	Existing	1880		
Penarth	Alexandra Park	Existing		Ollerton	
Penge	Alexandra Rec	Lost		McCallum & Hope, Ruchill Ironworks, Glasgow	
Penrith	Castle Park	Existing	1923		
Penzance	Morrab Gardens	Existing	1905	Walter MacFarlane & Co, Saracen Foundry, Glasgow	
Penzance	Promenade	Lost			
Perth	North Inch	Lost	1891		
Peterborough	Central Park	Lost		The Park, opposite All Saints Church	
Plumstead	The Common	Lost			
Plumstead	Bostall Woods	Lost			
Plymouth	Devonport Park	Lost			
Plymouth	Victoria Park	Lost			
Plymouth	The Hoe	Lost		George Smith & Co. Sun Foundry, Glasgow	
Pocklington	Burnby Hall Gardens	Existing	1994	Ollerton	
Pontypridd	Ynysangharad Park	Existing	1923		
Poole	Poole Park	Lost			
Port Talbot	Talbot Memorial Park	Existing	1925	Lion Foundry Co Ltd, Kirkintilloch	25
Porthcawl	John Street	Existing	1995		
Portland	Easton Gardens	Lost	1904	Hill & Smith, Brierley Hill, W. Midlands	
Portobello	Sea front Promenade	Lost			
Portrush	Gardens	Lost			
Portsmouth	Milton Park	Lost	1923		
Portsmouth	Victoria Park	Lost	1878		
Portsmouth	Southsea Castle	Lost		Walter MacFarlane & Co, Saracen Foundry, Glasgow	
Preston	Avenham Park	Lost	1919	Walter MacFarlane & Co, Saracen Foundry, Glasgow	225
Pudsey	Pudsey Park	Lost			
Radcliffe	Coronation Park	Lost			
Radcliffe	Town Square	Existing	1995		
Ramsbottom	Nuttall Park	Lost			
Ramsgate	Italian Gardens	Lost			
Ramsgate	East Cliff Promenade	Lost			
Ramsgate	Westcliff, St Lawrence Cliffs Estate	Lost	1930		
Ramsgate	Wellington Crescent	Existing	1939		
Ramsgate	Ellington Park	Existing	1900	Walter MacFarlane & Co, Saracen Foundry, Glasgow	279
Reading	Forbury Gardens	Existing	1905		
Redcar	Coatham sea front	Lost			
Redcar	Marske by the Sea	Lost			
Redcar	Esplanade	Existing	2008		
Redcar	Promenade	Lost			
Redcar	Zetland Park	Lost			
Redditch	Church Green West	Existing	1898		
Redruth	Victoria Park	Existing			
Renfrew	Robertston Park	Lost		Walter MacFarlane & Co, Saracen Foundry, Glasgow	
Retford	King's Park	Existing	1972		
Rhyl	The Pier	Lost	1867		
Rhyl	Promenade Gardens	Lost			
Ripley	Crossley Park	Existing	1935		
Ripon	Racecourse	Existing	1993		
Ripon	Spa Gardens	Existing	1903	Walter MacFarlane & Co, Saracen Foundry, Glasgow	279
Rochdale	Falinge Park	Lost	c.1913		
Rochdale	Broadfield Park	Existing	1893	Walter MacFarlane & Co, Saracen Foundry, Glasgow	249
Rochester	Castle Grounds	Existing	1871		
Romsey	War Memorial Park	Existing	2002	Heritage Engineering, Glasgow	
Ross on Wye	Carolyne Simmonds Park	Existing			
Rotherham	Clifton Park	Lost	1891	George Smith & Co. Sun Foundry, Glasgow	
Rotherham	Clifton Park	Existing	1928		
Rotherham	Rawmarsh, Rosehill, Victoria Park	Existing	1931		
Rotherham	Dinnington Gardens	Lost			
Rotherham	Maltby Model Village	Lost			
Rothesay	Ferry	Lost		Walter MacFarlane & Co, Saracen Foundry, Glasgow	
Rothesay	Victoria Street - Bay	Lost		Walter MacFarlane & Co, Saracen Foundry, Glasgow	
Royal Welsh showground					
Royston	Royston Park	Existing	c.1920	Walter MacFarlane & Co, Saracen Foundry, Glasgow	
Rugby	Caldecott Park	Existing	1908		
Rugby	Recreation Ground	Existing			
Runcorn	Runcorn Hill	Existing			
Rushden	Hall Park	Existing			
Ryde, Isle of Wight	Western Esplanade	Lost		Walter MacFarlane & Co, Saracen Foundry, Glasgow	
Saffron Walden	Jubilee Gardens	Existing	1993		
Sale	Worthington Park	Existing	1900		
Salisbury	Victoria Park	Lost			
Saltburn	Glenside	Existing	1996		
Saltburn	Hazel Grove	Lost			
Saltcoats, Ayrshire	Melbourne Park	Lost		Walter MacFarlane & Co, Saracen Foundry, Glasgow	249

Location	Site	Status	Date	Maker	No.
Sandown	Ferncliff Gardens	Existing	1982		
Sandown	Sandham Gardens	Existing	c.1950		
Sandwell	Haden Hill Park	Lost			
Scarborough	Peasholm Park	Existing	1929		
Scarborough	Spa	Existing	1913		
Scarborough	Spa	Lost	1858		
Scarborough	Esplanade	Lost	1874		
Scarborough	Clarence Gardens	Lost			
Sedgeley	Baggeridge Country Park	Existing			
Seisdon, Staffs	The Elms Gardens	Existing	1894	Walter MacFarlane & Co, Saracen Foundry, Glasgow	249
Selby	Selby Park	Existing	1993		
Seven Sisters	Recreation Ground	Existing	c.1920	WA Baker, Newport, Monmouthshire	
Sevenoaks	The Vine Recreation Ground	Existing	1894	Walter MacFarlane & Co, Saracen Foundry, Glasgow	224
Shanklin	Rylstone Gardens	Existing	1973		
Sheerness	Sea Front	Lost	1897		
Sheffield	Weston Park	Existing	1875	James Allan Sen & Son, Elmbank Foundry	
Sheffield	Chapeltown Park	Lost			
Sheffield	Hillsborough Park	Lost		James Allan Sen & Son, Elmbank Foundry	
Sheffield	Endcliffe Woods Park	Lost		James Allan Sen & Son, Elmbank Foundry	
Sheffield	Meersbrook Park	Lost			
Sheffield	Firth Park	Lost			
Sheffield	The Moor Shopping Centre	Existing	1986		
Sheffield	Botanical Gardens	Lost		Coalbrookdale Iron Company	
Shepton Mallet	Collet Park	Existing	1908		
Sherborne	Pageant Gardens	Existing	1906	James Allan Sen & Son, Elmbank Foundry	
Shildon	Hackworth Park	Existing	1913	David Rowell, London	
Shipley	Crowgill Park	Lost			
Shoreditch	Arnold Circus	Existing			
Shotts		Lost		Lion Foundry Co Ltd, Kirkintilloch	54
Shrewsbury	The Quarry	Existing	1887	McDowall, Steven & Co, Milton Ironworks, Glasgow	
Sidmouth	Connaught Gardens	Existing	1934		
Skegness	Tower Gardens	Existing	1996		
Skegness	Bathing Pool	Lost			
Skelmersdale	The Park	Lost			
Slaithwaite	The Spa	Lost	c.1890		
Sleaford	The Riverside	Existing	1989		
Soham	Cherry Tree Public House	Existing			
Southbourne	Fishermans Walk Gardens	Existing			
South Rauceby	Greylees	Existing			
South Shields	Sea Road	Existing	1931		
South Shields	South Marine Park	Existing	1904	Walter MacFarlane & Co, Saracen Foundry, Glasgow	
Southampton	Palmerston Park	Existing	2000	Ollerton	
Southend on Sea	Priory Park	Existing	1990	Bandstands Ltd	
Southend on Sea	Happy Valley	Lost	1899		
Southend on Sea	Happy Valley	Lost	1909		
Southend on Sea	Chalkwell Park, Westcliff	Lost	1896	Walter MacFarlane & Co, Saracen Foundry, Glasgow	
Southend on Sea	Pier Hill Buildings	Lost	1898		
Southend on Sea	The Pier	Lost	1909		
Southend on Sea	Cliff Parade, West Cliff	Lost			
Southend on Sea	East Parade, Pawley's Green	Lost	1904	Walter MacFarlane & Co, Saracen Foundry, Glasgow	
Southend on Sea	The Cliffs	Lost	1909	Walter MacFarlane & Co, Saracen Foundry, Glasgow	
Southend on Sea	The Cliffs	Lost	1957	Goodwins Store Fitters Ltd	
Southport	Cambridge Hall Gardens	Lost			
Southport	The Enclosure	Lost			
Southport	Botanical Gardens	Lost		small ice cream kiosk	
Southport	Municipal Gardens, Lord St	Lost			
Southport	Municipal Gardens, Lord Street	Existing	1986	Bandstands Ltd	
Southport	Victoria Park	Existing	1912	Lion Foundry Co Ltd, Kirkintilloch	23
Southsea	South Parade Pier	Lost	1907		
Southsea	Common	Existing	1928	Sadler and Co.	
Southsea	West Battery Field	Existing	1996		
Southwark	Red Cross Garden	Existing			
Spennymoor	High Street	Existing	1991		
Spennymoor	Spennymoor Junction	Lost	1925	Lion Foundry Co Ltd, Kirkintilloch	42
Spennymoor	Jubilee Park	Existing	1911	James Allan Sen & Son, Elmbank Foundry	
St Annes, Lytham	Promenade Gardens	Lost	1908	Lion Foundry Co Ltd, Kirkintilloch	
St Annes, Lytham	Lowther Park	Lost			
St Annes, Lytham	Promenade Gardens	Existing	1900	Walter MacFarlane & Co, Saracen Foundry, Glasgow	279
St. Albans	The Maltings	Existing	1983		
St. Albans	Clarence Park	Existing	1998	Ollerton	
St. Andrews	Sea Front	Existing	1905	Walter MacFarlane & Co, Saracen Foundry, Glasgow	279
St. Helens	Taylor Park	Lost			
St. Leonards	Warrior Square	Existing	1974		
St. Osyth	Point Clear	Existing	1982		
Stafford	Victoria Park	Existing	1905	Coalbrookdale	
Stafford	The Riverside	Existing	1989		

Town	Park	Status	Date	Manufacturer	Ref
Staines	The Lammas	Existing	1920		
Stamford	Recreation Ground	Existing	c.1910		
Stirling	King's Park	Existing	c.1925		
Stockport	Vernon Park	Existing	2001	Heritage Engineering	
Stockport	Cale Green Park	Existing			
Stockton-on-Tees	Ropner Park	Existing		Walter MacFarlane & Co, Saracen Foundry, Glasgow	279
Stoke-on-Trent	Burslem Park	Existing			
Stoke-on-Trent	Hanley Park	Existing	1894	Walter MacFarlane & Co, Saracen Foundry, Glasgow	279
Stoke-on-Trent	Longton Park	Existing		Hill & Smith, Brierley Hill, W. Midlands	
Stonehouse	Alexander Hamilton Park	Existing	1911		
Stoneleigh	National Agricultural Centre	Existing	1965		
Stourbridge	Stevens Park, Wollescote	Lost	1932		
Stourbridge	Stevens Park, Quarry Bank	Existing	1925	Lion Foundry Co Ltd, Kirkintilloch	
Stourbridge	Promenade Gardens	Lost			
Stourbridge	Mary Stevens Park	Existing	1929	Hill & Smith, Brierley Hill, W. Midlands	
Stourport on Severn	War Memorial Park	Existing	c.1880	Walter MacFarlane & Co, Saracen Foundry, Glasgow	225
Stourport on Severn	Riverside Gardens	Existing	2003		
Stranraer	Stair Park	Existing	1911	Walter MacFarlane & Co, Saracen Foundry, Glasgow	279
Stratford upon Avon	Recreation Meadow	Existing			
Strathhaven	George Allan Park	Existing	1902	Walter MacFarlane & Co, Saracen Foundry, Glasgow	279
Stroud	Stratford Park	Existing	1986		
Sunderland	Mowbray Gardens	Existing	1883	Lockerbie and Wilkinson / Heritage Engineering	
Sunderland	Barnes Park	Existing	1909	W.A. Baker & Sons, Newport, Monmouthshire	
Sunderland	Roker Park	Existing	1880	McDowall, Steven & Co, Milton Ironworks, Glasgow	
Swadlincote	Maurice Lea Memorial Park	Existing		Hill & Smith, Brierley Hill, W. Midlands	
Swanage	Beach Gardens Recreation Ground	Existing	1923	Walter MacFarlane & Co, Saracen Foundry, Glasgow	224
Swansea	Ravenhill Park	Existing	c.1930		
Swansea	Manselton Park	Existing	c.1930		
Swindon	Quarry Road Town Gardens	Lost		Hill & Smith, Brierley Hill, W. Midlands	
Swindon	Town Gardens	Existing	1936		
Swindon	Town Gardens	Existing	1894	James Allan Sen & Son, Elmbank Foundry	
Swindon	Faringdon GWR Park	Lost			
Swindon	Lydiard park	Existing			
Swinton	Victoria Park	Existing	1897	Robert Hall	
Syston	Town Centre	Existing	1989	Dorothea	
Tamworth	Castle Grounds	Existing	1900		
Taunton	The Riverside	Existing			
Taunton	Vivary Park	Existing	1895	Walter MacFarlane & Co, Saracen Foundry, Glasgow	249
Taunton	Wellington Park	Existing	1903		
Tavistock	Tavistock Meadows	Existing	1935		
Telford	Hartshill Memorial Park	Existing	c.1950		
Telford	Town Park	Existing	c.1900		
Tenby	St Catherine's Island	Lost			
Tenby	Castle Hill	Existing	1991	Dorothea	
Tewkesbury	Victoria Pleasure Grounds	Lost			
Thame	Church Road	Existing	1880	Walter MacFarlane & Co, Saracen Foundry, Glasgow	296
Thorne	Public Park	Existing	1922	Lion Foundry Co Ltd, Kirkintilloch	43
Tiverton	West Exe Park	Existing	1900		
Todmorden	Centre Vale Park	Existing	1914		
Tollard Royal	Larmer Tree Gardens	Existing	1895		
Torquay	Princess Gardens	Existing	1985		
Torquay	Pavilion	Existing	1912	Falkirk Iron Co. Ltd	
Torquay	Babbacombe Downs	Lost			
Tower Hamlets	Island Gardens	Existing			
Tranent	Polson Park	Existing	1932		
Tredegar	Bedwellty Park	Existing	1912	Hill & Smith, Brierley Hill, W. Midlands	
Treharris	Treharris Park	Existing	c.1935	Hill & Smith, Brierley Hill, W. Midlands	
Trentham	Trentham Gardens	Existing	c.1910		
Troon	Seafront	Lost	1907	Walter MacFarlane & Co, Saracen Foundry, Glasgow	249
Trowbridge	Peoples Park	Lost			
Trowbridge	Trowbridge Park	Existing	1939		
Truro	Victoria Gardens	Existing	1898	W.A. Baker & Sons, Newport, Monmouthshire	
Tunbridge Wells	The Pantiles	Existing	1739		
Tunbridge Wells	Grosvenor Recreation Ground	Lost			
Tunbridge Wells	The Pantiles	Existing	1979		
Tunbridge Wells	Calverley Park	Lost	1924	Walter MacFarlane & Co, Saracen Foundry, Glasgow	
Tunstall	Tunstall Park	Existing	1904		
Uttoxeter	Bramshall Park	Existing			
Uxbridge	Fassnidge Park	Existing	1926	Walter MacFarlane & Co, Saracen Foundry, Glasgow	224
Ventnor	Ventnor Park	Existing	1887	Walter MacFarlane & Co, Saracen Foundry, Glasgow	
Wakefield	Clarence Park	Lost	1893		
Wakefield	Clarence Park	Existing	1926		

Walkden, Lancs	Parr Fold Park	Existing	1930		
Wallasey	Vale Park	Existing			
Wallsend	Richardson Dees Park	Existing	c.1925		
Wallsend	Wallsend Park	Existing	1900		
Walmer	Sea Front	Existing			
Walsall	Walsall Arboretum	Existing	1924	Walter MacFarlane & Co, Saracen Foundry, Glasgow	
Walsall	Willenhall Memorial Park	Existing	1999		
Walsall	Palfrey Park	Existing	1890	George Smith & Co. Sun Foundry, Glasgow	
Waltham Forest	Coronation Gardens	Existing			
Wantage	Manor Road Recreation Ground	Existing	1988		
Ware	Priory Park	Existing	c.1960		
Warminster	Lake Pleasure Gardens	Existing	1924		
Warrenpoint	Municipal Park	Existing	1907	Walter MacFarlane & Co, Saracen Foundry, Glasgow	249
Warrington	Public Park	Lost			
Warrington	Walton Hall Gardens	Existing	c.1950		
Watford	Cassiobury Park	Existing	1914	Hill & Smith, Brierley Hill, W. Midlands	
Wednesbury	Brunswick Park	Existing	1928		
Wellingborough	Bassetts Park	Existing	c.1910		
Wellingborough	Castle Fields	Existing	1913		
Wellington	Wellington Park	Existing			
Wells	Recreation Ground	Existing	1965		
West Bromwich	Hill Top Park	Lost			
West Bromwich	Farley Park	Lost			
West Bromwich	Victoria Park, Tipton	Lost			
West Bromwich	Dartmouth Park	Lost			
Westbrook, Kent	Sea Front	Lost		Walter MacFarlane & Co, Saracen Foundry, Glasgow	249
Westbury on Trym	Canford Park	Lost			
Westgate on Sea	Coronation bandstand	Lost	1903		
Weston-super-Mare	New Pier	Lost			
Weston-super-Mare	Promenade	Lost			
Weston-super-Mare	Rozel	Lost			
Weston-super-Mare	Grove Park	Existing	1891	Sun Foundry, Alloa	
Wetherby	The Wilderness	Existing	2000	Ollerton	
Weymouth	Alexandra Gardens	Lost	1891	Walter MacFarlane & Co, Saracen Foundry, Glasgow	279
Weymouth	Pier	Lost	1939		
Weymouth	Esplanade	Lost	1907		
Weymouth	Brunswick Terrace	Lost			
Weymouth	Nothe Gardens	Lost		Walter MacFarlane & Co, Saracen Foundry, Glasgow	279
Whitby	The Saloon	Lost			
Whitby	Pier	Existing	c.1960		
Whitchurch	Jubilee Park	Existing	1900	Walter MacFarlane & Co, Saracen Foundry, Glasgow	
Whitehaven	Castle Park	Existing	1936		
Whitley Bay	Northumberland Park	Existing			
Widnes	Victoria Park	Existing	1903	Walter MacFarlane & Co, Saracen Foundry, Glasgow	279
Wigan	Mesnes Park	Existing	1891	George Smith & Co. Sun Foundry, Glasgow	
Wigston	Peace Memorial Park	Existing	2000		
Willesden	Gladstone Park	Lost			
Windsor	Jubilee Gardens	Existing	2002		
Windsor	Alexandra Gardens	Lost	1901	Lion Foundry Co Ltd, Kirkintilloch	
Wisbech	The Park	Existing	1908	Hill & Smith, Brierley Hill, W. Midlands	
Wishaw	Belhaven Park	Lost			
Withernsea	Valley Gardens	Existing	2002		
Withernsea	Sea Front	Lost			
Woking	Town Centre	Existing	1989	Dorothea	
Wolverhampton	East Park	Existing	1896	Walter MacFarlane & Co, Saracen Foundry, Glasgow	249
Wolverhampton	West Park	Existing	1882	McDowall, Steven & Co, Milton Ironworks, Glasgow	
Wolverton	Wolverton Park	Lost			
Woodbridge	Riverfront	Existing	1986		
Woodbridge	Elmhirst Park	Existing	1998		
Woodhall Spa, Lincs	St Georges Drive	Existing	2004		
Woodhall Spa, Lincs	Treatment Baths	Lost	1888		
Woodhall Spa, Lincs	Jubilee Park	Existing	1935		
Worcester	Gheluvelt Park	Existing	1922	James Allan Sen & Son, Elmbank Foundry	
Worksop	Clumber Park	Existing			
Worthing	Sea Front birdcage	Lost	1897	Walter MacFarlane & Co, Saracen Foundry, Glasgow	
Worthing	Steyne Gardens	Lost			
Worthing	Sea Front Lido	Existing	1929	Adshead and Ramsey	
Wrexham	Ponciau Banks Park	Lost	1914	Hill & Smith, Brierley Hill, W. Midlands	
Wrexham	Ponciau Banks Park	Existing	2009		
Wrexham	Llwn Isaf Gardens	Existing	1991	Ollerton	
Wrexham	Bellevue Park (Parciau)	Existing	1906		
York	Knavesmire	Lost			
York	Rowntree Park	Existing			
Youghall	Promenade	Existing		McDowall, Steven & Co, Milton Ironworks, Glasgow	